How to Draw
INCREDIBLE
OPTICAL
ILLUSIONS

Gianni A. Sarcone

imagine!
Publishing

An Imagine Book
Published by Charlesbridge
85 Main Street
Watertown, MA 02472
617-926-0329
www.charlesbridge.com

Copyright © 2015 by Gianni A. Sarcone
Interior and cover design by Melissa Gerber

Library of Congress Cataloging-in-Publication Data
Sarcone, Gianni A.
How to draw incredible optical illusions / Gianni Sarcone.
 pages cm
ISBN 978-1-62354-060-9 (softcover)
ISBN 978-1-60734-959-4 (ebook)
ISBN 978-1-60734-960-0 (ebook pdf)
1. Optical illusions in art. 2. Drawing—Technique. I. Title.
N7430.5.S264 2015
741.2—dc23 2014036849

Printed in China, April 2015
10 9 8 7 6 5 4 3 2 1

For information about custom editions, special sales, premium and corporate purchases,
please contact Charlesbridge Publishing at specialsales@charlesbridge.com.

Contents

Introduction

CLEAR AND EASY-TO-FOLLOW ILLUSTRATED DIRECTIONS

This book dissects the most fascinating and confounding black-and-white optical illusions, patterns and tiling, explaining in a concise fashion how they work, how to design and create them, and how to personalize and play with them to your heart's content. With accessible yet illuminating text and workable samples, this intriguing art "cookbook" is appropriate for graphic designers, teachers, artists, art lovers and the curious who enjoy contemplating how the mind works and how the eye sees.

HOW TO DRAW INCREDIBLE BLACK-AND-WHITE OPTICAL ILLUSIONS

PREAMBLE

The essence of Optic Art (or Op Art), the main topic of this book, is to play with our optic nerves, to surprise and to create the illusion of shades, dimensions and motion. Blank spaces, negative spaces, XOR spaces, interspaces, interferences, aliasing, and repetitive geometric textures are the palette the Op Artist uses to create powerful optical illusions and visual effects.

But Optic Art isn't only based on repetitive patterns that alternate optical contrasts (clear/dark, vertical/horizontal, straight/oblique, thick/thin, and so on). It is mostly a type of research that tries to achieve the maximum visual effect with the most minimal intervention. Some Op Art paintings are in fact both simple and effective.

Optic Art involves the understanding of how our neural mechanism of vision works, and the unceasing investigation of new mediums and techniques in the field of visual design to achieve the best optical effects.

With the aid of this book and a little patience, you will be able to draw impressive optical illusions in a reasonable amount of time. The book is geared toward freelance artists and designers and is not intended to serve as a substitute for art class; you will need a basic knowledge of fine arts and digital art to enjoy it—but the visuals are easy to follow and you can use your preferred art medium or technique to achieve your desired optical effect.

The book contains a collection of my best works showing recent and revisited optical-illusion effects, along with demonstrations and tips to inspire you to create your own work. The different optical

illusions are organized by effects and applications, such as self-moving static patterns, impossible or ambiguous figures, shade effects and distortion effects, presented in a way I hope will make it easy for you to put them into practice.

The emphasis of the book is on geometric and abstract imagery and on encouraging your own experimentation and discovery: using the examples in the book as a graphic resource, you may compare and combine them to create your own optical-illusion compositions. The main purpose, of course, is to prompt you to exercise your most valuable resource—your creativity.

VISUAL ILLUSIONS

Optical illusion is a particular style of art that plays tricks on our eyes and consequently baffles our perception. You might almost attribute the effect to faulty vision; in fact, these visual tricks are sometimes used to assess the performance of the eye or the brain.

While what you see obviously depends on your eyes, it is the job of the brain to make sense of that information. Via the optic nerves, the brain receives electrical signals from the eyes, which are thereafter converted into the sense of sight. Yet the brain adds some extra ingredients to the received image, such as attention, memory and meaning. We actually "see" by comparing images from the outside world with the models inscribed in our memory.

Each new object or visual experience is encoded in our memory and subsequently modifies the way we perceive things. Sometimes memory clashes with perception, when the stored model and the perceived image seem both coherent and incompatible, conveying double or contradictory meanings to the brain. At other times, the nature of our visual system itself causes visual interferences, such as seeing an object as blurred or vibrating. Whichever may be the case, when your brain gets it wrong, the result is an optical illusion.

The brain is a kind of device with known performances, whose internal workings are not completely understood but can be viewed in terms of outputs in relation to inputs. Since the Renaissance, scientists have been studying optical illusions to better understand how the brain interprets information (input data) and builds a representation of the surrounding world (output data). Meanwhile, architects, fine artists and designers have all regularly made practical use of optical illusions to aesthetically enhance the appearance of their creations, because real things often appear deceptive and "discordant." The idea, of course, is to produce a pleasant sensory quality in the building, painting or object, or sometimes to impress the viewer by creating objects in space that seem larger or smaller than they really are.

To joke and play tricks is also a feature of our human nature, and some artists create optical illusions in their artworks as an intellectual game—but also as a challenge, because the means to create visual illusions have always been of a scientific or technical nature: illusive perspective, visual distortions or even visual ambiguities could never be created without an understanding of what lies behind them.

In fact, most optical illusions were first discovered by artists and designers who produced textures and patterns while working within the wide range of the creative arts and crafts, long before they were rediscovered and "officially" described by scientists.

IN THE BEGINNING WAS THE LINE

The French painter Edgar Degas once said that art is not what you see, but what you make others see. The most visible and crucial element in art is the "line": it indicates the edge of a flat shape or a solid form. A flat shape can be indicated by means of an outline, while a three-dimensional form can be indicated by contour lines.

So, drawing is per se an optical illusion: in fact, an artist is able to magically convert the real 3D world or any object from his or her imagination into a flat image thanks to a powerful tool: the line!

Drawing is certainly a mental act, but it also requires physical action. We can find the root of this physical action in language itself. For instance, the Latin verbs for drawing are *delineare* and *describere*, which, translated literally, mean, "to draw lines with the help of a linen cord" and "to scratch, trace signs." The English verb "to draw" comes from Indo-European *dhragh,* meaning "to draw, drag on the ground."

Scratching or tracing lines on rocks or in the sand must surely have been man's first attempt at art (doodling is actually a very strong natural tendency!). Many examples of this type of early art have been found in caves. It is possible that the very first lines traced by humans were intended to have a magic purpose. In fact, the South African cognitive archaeologist David Lewis-Williams has rehabilitated the interpretation of Paleolithic cave art as a form of magic by focusing on the geometric images appearing in great numbers on the cave walls. Lewis-Williams argues that these geometric images are actually subjective "entoptic images" that the early artist might have experienced under an altered state of consciousness. Entoptic images can be subdivided into six visual types:

1) grid/net

2) parallel strokes

3) random dots or spots

4) zigzag lines

5) curvilinear lines

6) dendriform or meandering lines (having the shape of a tree or maze).

In normal visual perception, we see objects in the external world when light stimulates the appropriate set of cells inside our eyes. This information is then encoded and translated into coherent images through the multiple layers of our brain. By contrast, entoptic images are not external visual objects, but rather geometric visual hallucinations that emanate from within the brain itself. They become apparent in our visual field when the brain is destabilized in certain ways—through sensory deprivation, rhythmic chanting or drumming, flickering lights and certain forms of dance, as well as the ingestion of hallucinogenic stimulants. In conclusion, according to Lewis-Williams, the origin of line art is closely linked to magic visions induced in the context of shamanic trances and ritual practices.

Our early ancestors understood that lines could be powerful tools to depict or represent the real or the imaginary world or to leave a trace of one's existence. This discovery was linked to the ability to

mentally identify themselves as thinking individuals, separate from others or the surrounding world. In other words, the act of drawing was closely linked to the development of a full "consciousness of self." Tracing lines was and still is like leaving a personal record: "Hello, I was here!" Time may erase our memories, but not what is drawn.

Since then, a lot of progress has been made in the field of visual art and we are now able to see, understand and reproduce complex pictures. In fact, everyone nowadays can produce, handle, manage and share pictures, thanks to digital media and the Internet.

WHAT YOU WILL NEED

The materials and equipment required to create optic patterns and illusive visual effects depend first upon your own ability: with a good ruler, a pair of compasses, pencils, pens and some patience you should be able to reproduce all the examples in this book without any difficulty. Some will involve tracing images in order to duplicate them, for which you can use tracing paper or a light box.

You are also encouraged to use your favorite drawing software program (vector and/or bitmap) or other modern devices such as a scanner or photocopier to help you achieve the best visual effect. But do not expect to create a masterpiece on the first attempt—it is very important to create as many sketches as possible before you start the final realization of your optical-illusion picture.

Size Distortion

DRAWING SIMPLE OPTICAL ILLUSIONS USING LINES

The German painter Paul Klee once said, "A line is a dot that went for a walk," and he was largely right! Two distant points can always be joined together by a straight line; in fact, it was by connecting prominent stars of the welkin with an imaginary line that early man created the first representation of the constellations.

In the rigorous world of mathematics, a line is a straight or curved continuous extent of length without breadth. In art, however, it is the fundamental element without which nothing can be outlined or represented: it is the essential surge that flows from the artist's hand.

A line can be cut into segments. With two small segments it is possible to create simple but essential figures such as L, V, T and X. But even the simplest geometrical optical illusion can produce strong visual effects. An example of this is the early T-illusion, described by the Italian mathematician Luca Pacioli in his book *De Viribus Quantitatis*, published in 1510. Have a look at the capital T below. Each bar of the letter is exactly the same length, yet the vertical bar seems longer. You will discover in this book that some optical illusions are very difficult to overcome; they remain compelling even when you are fully aware that what you see is wrong.

So, in optical illusions lines and segments are important, and especially the oblique segments and those particular combinations of segments called crosses and chevrons (also known as herringbones).

This is the simplest illusion ever. Just draw two lines of equal length (Fig. 1). Then, at each end of one line, place two segments in the shape of a right-angled V (or of an angle bracket) pointing outward, as shown in Fig. 2a. At each end of the second line, place an identical V shape, but this time pointing inward (Fig. 2b). Now the second line looks much longer than the first, even though they are the same length. The V-shaped segments, or chevrons, are present in many optical illusions, as you will discover in the following pages.

1.

2.

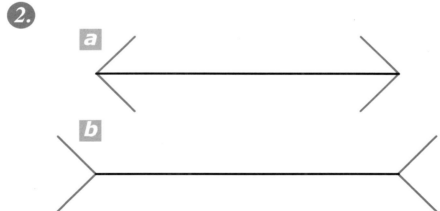

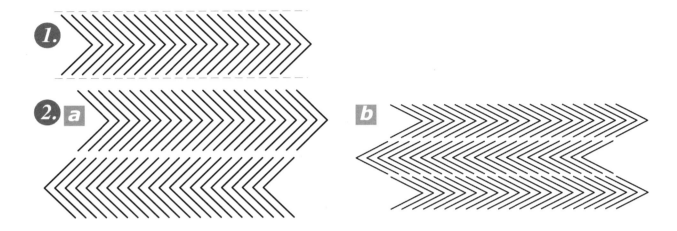

In 1860, the German astrophysicist Johann Karl Zöllner noticed that in a herringbone pattern designed for a dress fabric, the parallel lines appeared to be divergent and wrote an article on this optical illusion. The classic Zöllner illusion traditionally represents a series of oblique parallel lines intersected by transversals (see facing page; Fig. 2a).

Fig. 1 shows a set of chevrons, pointing to the right and all exactly aligned and parallel. In a herringbone pattern, the adjoining row of chevrons points in the opposite direction (Fig. 2a). The more acute the angle of the chevrons, the stronger the illusion will be (Fig. 2b). In Fig. 3a (and its negative picture in Fig. 3b) you can see that the alignments of chevrons within the pattern appear to converge toward and diverge away from each other.

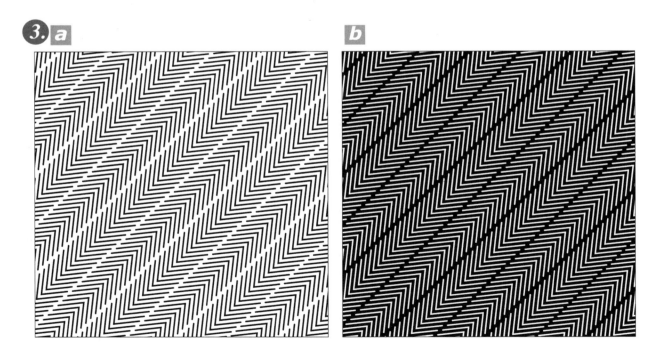

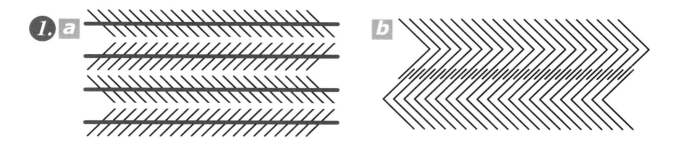

If we trace alternating gray and white parallel lines on the herringbone alignments, as shown here in Fig. 1a, we obtain the classic Zöllner illusion (see the whole pattern in Fig. 2a) and incidentally increase the virtual tilting effect of the pattern.

In Fig. 2a the lines seem not to be parallel, though they are in reality perfectly so. This is because the brain misinterprets a series of straight lines in contrast to other regular lines that are perceived as background elements. In fact, every array of short oblique segments (Fig. 1a) is interpreted by our brain as a whole seamless oblique line leaning in the direction of the segments. If a transversal line is traced on this array of parallel oblique segments, the brain "overcorrects" the tilting impression of the pattern in the background and, in doing that, it unintentionally makes the straight line in the foreground appear to slant in the opposite direction of the leaning segments. We can compare this "overcorrective" response (which is probably governed by orientation-specific neurons in the visual cortex) to another everyday phenomenon: when you stand in a vehicle such as a train, your body tends to oppose the direction of the motion. This balancing effect is a natural reflex.

Figs. 1b and 2b are an interesting variant of the Zöllner illusion by Gianni A. Sarcone.

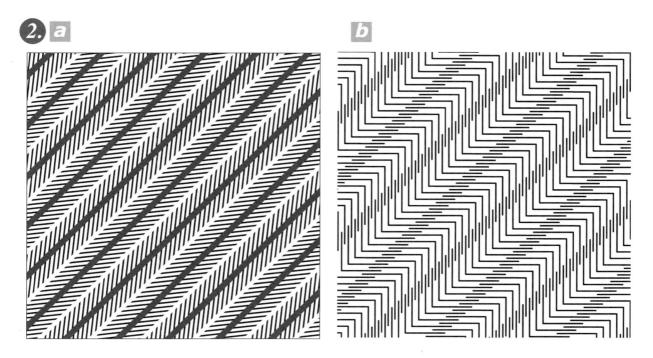

The Zöllner illusion can also induce a self-moving effect. The simplest way to experiment with it is to "abridge" the illusion into two simple oblique lines (Fig. 3a). Fix your gaze at the intersection of the lines, then move the page toward your nose and back the other way. The oblique line will start to move or slide slightly. In the image in Fig. 3b the self-sliding effect is enhanced. In fact, you do not have to move either your head or the image to make the illusion work, though the effect works best when seen through peripheral vision.

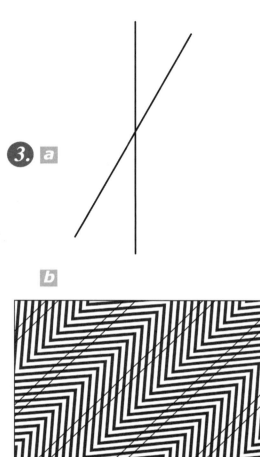

3. **a**

b

1.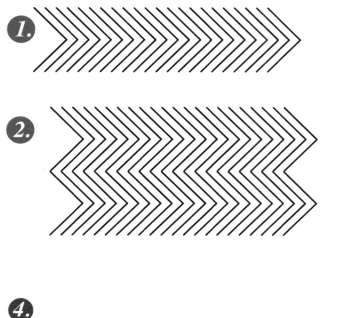

2.

3. **a**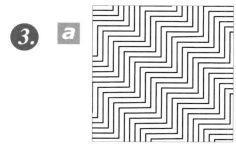

b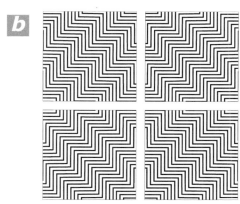

4.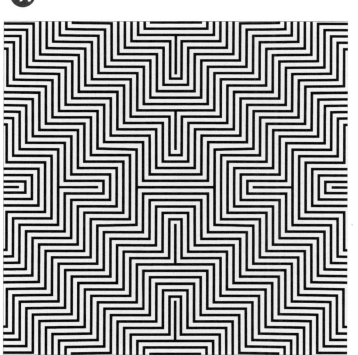

Using chevron-like elements, you can build an intriguing pattern that vibrates and flickers. Simply draw an alignment of chevron-like elements, as shown in Fig. 1 (note that the two strokes of every V-shaped element join at ninety degrees). Then reproduce those chevron alignments, one upon the other (Fig. 2), to create a whole seamless pattern. Embed the arranged sets of chevrons into a square frame (Fig. 3a). By rotation and reflection, you will obtain four different configurations from the same square cell (Fig. 3b). Finally, assemble the four cells together to obtain an amazing flickering pattern (Fig. 4).

Look at the final result above—no matter how hard you try to hold your eye still, it is exhausting! The perturbing optic effect arises because there are so many lines with contrasting orientation close together —the eye is unable to make small enough scans to identify the position of individual lines. Moreover, the lines seem to organize themselves into diamond-like frames that appear to advance or to recede.

TWISTED LETTERS

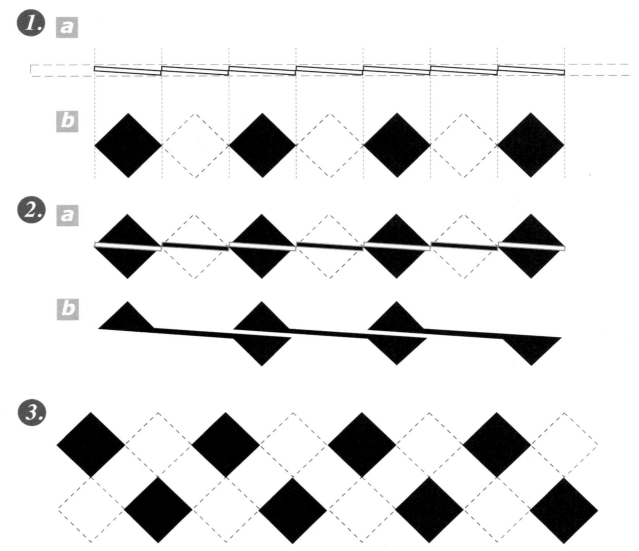

An array of slightly oblique segments (Fig. 1a) can generate interesting tilting or bending effects when merged with an orthogonal arrangement of rhombi (Fig. 3). This tilting effect can be applied many ways, but, as you will notice, when it is applied to capital letters it gives the most perturbing result (capital letters that work best are E, F, H, I, L and T).

First, you need to understand how to draw the basic elements of the illusion (Fig. 2b); the diagrams in Figs. 1 and 2 show how to trace them by using the oblique segments as a guide. Obviously, if you don't use a vector graphic editor like Illustrator or Freehand, some tracing paper or a light-box could be of help to create such interesting patterns.

As you can see in the three examples opposite, the letters of the words LIFE, TILT and HELL are delineated by perfectly aligned rhombi, but they look nevertheless slanted! In fact, the overall outline of the capital letters appears to lean toward the tilt of the segments that each join two rhombi together.

To be more specific, the basis of this optical design is the polar coordinate distortion (reverse) of the famous Fraser illusion.

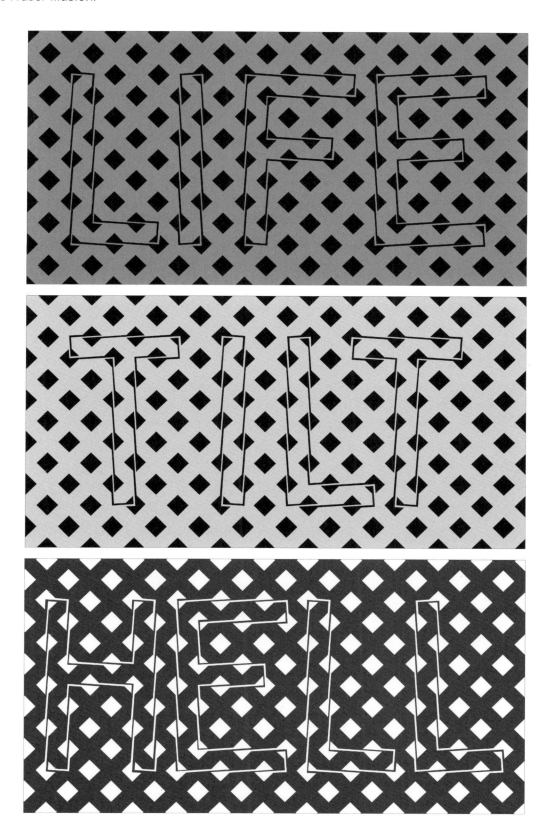

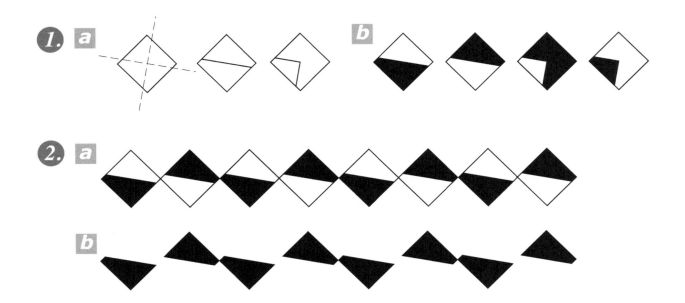

Here is an interesting variant: with the same arrangement of rhombi it is possible to create letters with another illusive tilting effect by inserting the basic elements shown in Fig. 2b over the background (the simple step-by-step diagrams in Figs. 1a, 1b and 2a show how to trace these basic elements). The word TILT seems to "dance" within the pattern, in spite of the fact that each single letter is perfectly straight!

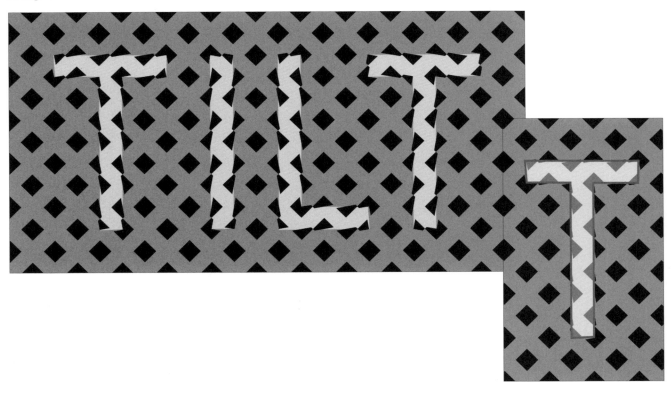

DISTORTION EFFECT

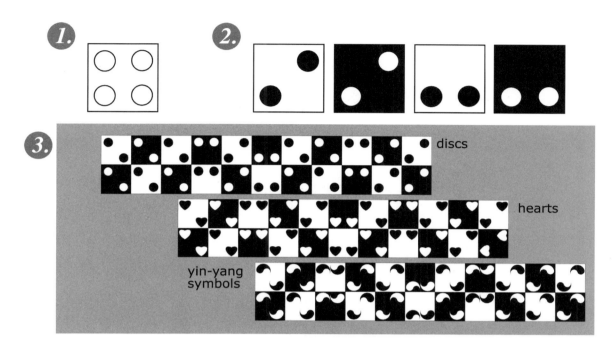

The way that the brain interprets what the eye sees depends upon context. Some interesting shape-distortion effects can be produced by the interaction between the actual shape of the object (in this case a square) arranged within a pattern and the shapes of nearby elements (the small contrasting discs).

Start with a square (Fig. 1)—the four blank circles shown here are a guide to how to distribute the black discs or figurative elements within the square. On four separate squares, draw discs placed diagonally or aligned at the bottom. Render them in two alternating colors (Fig. 2). Assemble the squares of Fig. 2 in a double-row checkered arrangement (Fig. 3). Instead of small discs you can also use other motifs such as hearts or yin-yang symbols.

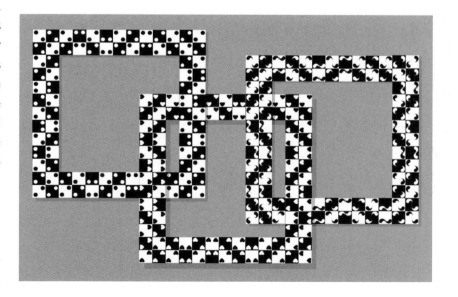

By assembling four similar double-row arrangements you can now make interesting checkered square frames (see above). If you have done it correctly, the square frames should look wavy even though they are perfectly straight.

To enhance the wavy effect you can also distribute the two-color tiles in order to form three concentric checkered square frames, as shown here below.

Yes, everything is straight in this picture!

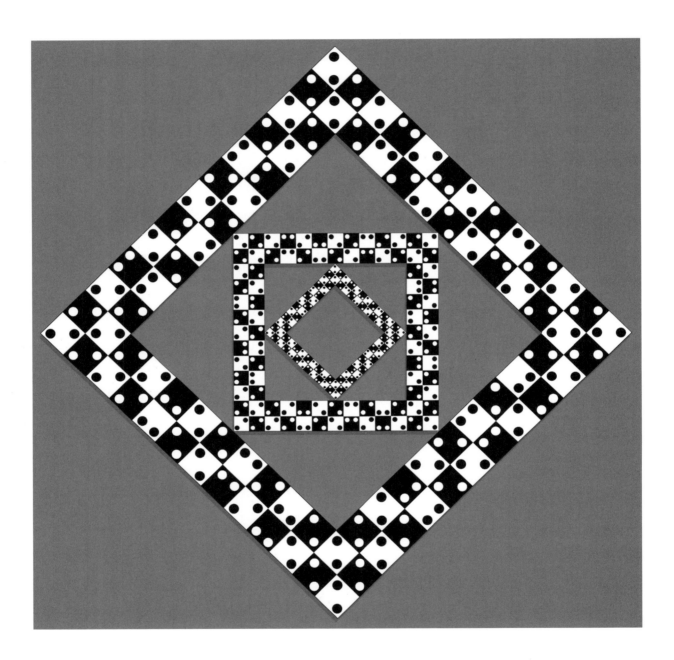

This design is based on the "pursuit curves" that would be formed if four dogs set off to chase each other from the corners of a square field. The path created by each dog is an equiangular spiral.

First draw a large square (Fig. 1a), and then turn every following square five degrees around its center (Fig. 1b) and compress it at the same time (approximately 96 percent reduction at each step), so that its four corners touch the sides of the preceding square (Fig. 2). As you add more squares, the corners form four hypnotic spiral arms. Those spirals belong to the large family of the logarithmic spirals that often appear in nature. Wonderful examples are found in shells, such as those of the nautilus and fossil ammonites, or even in spiders' webs. By reflection and rotation you can create interesting, surrealistic patterns. You can also add contrast by alternately filling spaces with black color.

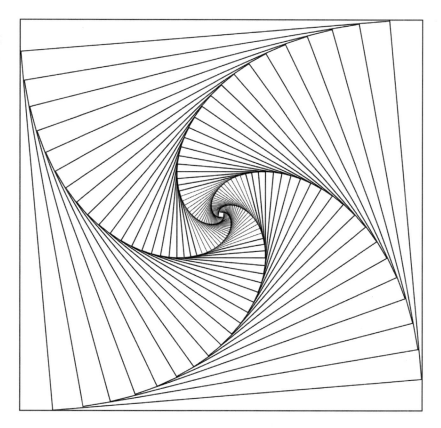

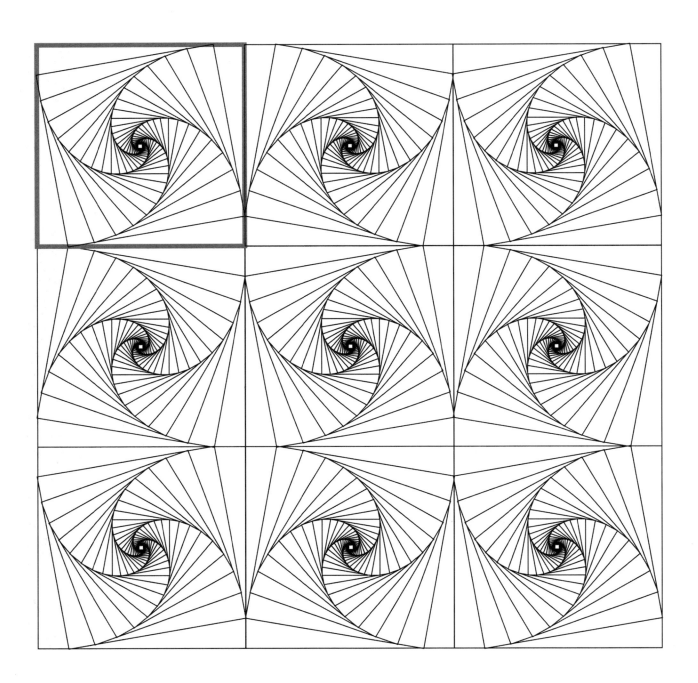

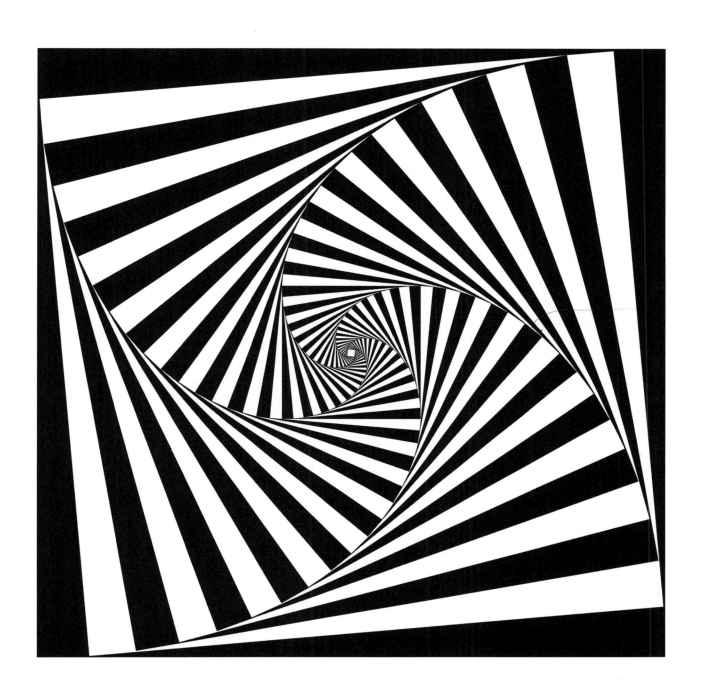

WOBBLING EFFECT

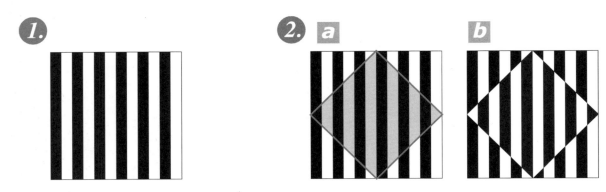

To make the basic cell of the pattern below, simply draw a set of regular vertical stripes within a square (Fig. 1). Then draw a smaller square with corners touching the sides of the larger square (Fig. 2a), and invert the color of the stripes (Fig. 2b).

In a repeating pattern, the diagonally placed squares seem to have wobbly corners and to move slightly.

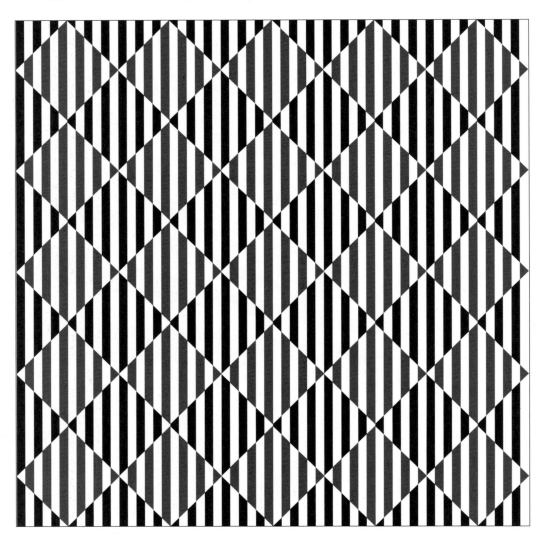

If you use Photoshop, you can enhance the overall shifting movement by overlaying a copy of the pattern and blending it with the original in difference or exclusion mode (negative). You can do the same with Illustrator or Freehand vector software (using inverse mode). The final arrangement of diamonds produces a fish-eye lens effect that gives the strong impression of a shifting movement.

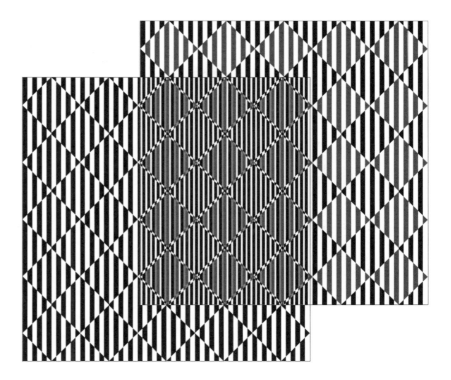

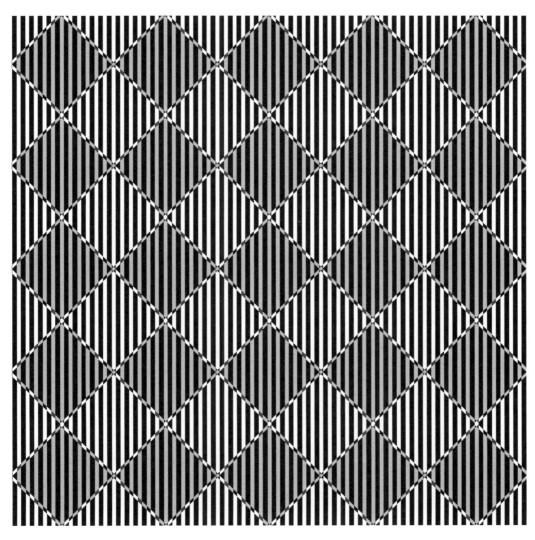

BULGING EFFECT

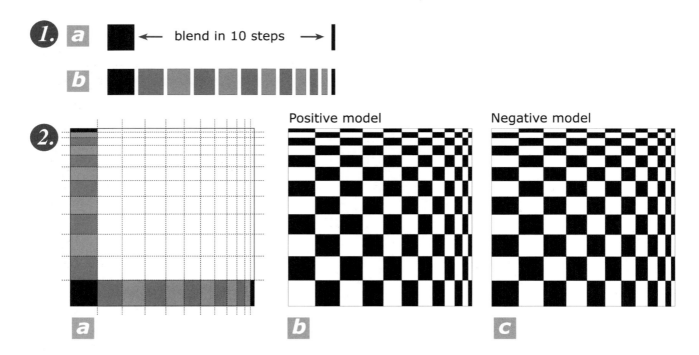

1. **a** ← blend in 10 steps →

b

2.

a

Positive model

b

Negative model

c

You can easily create this checkered bulging effect with the help of the *blend* tool of Illustrator cr Freehand, which allows you to blend one shape into another one. If you do not use either of these drawing software packages, you can sketch the basic model on graph paper.

Blend a square into a thinner rectangle in ten or eleven steps (Figs. 1a and 1b). Next, use the resulting rectangles as a guide to draw lines (logarithmic coordinates) within a square, as shown in Fig. 2a. Fill the vertical and horizontal lines outlined by the series of rectangles with alternating colors (Figs. 2b and 2c).

3.

a

b

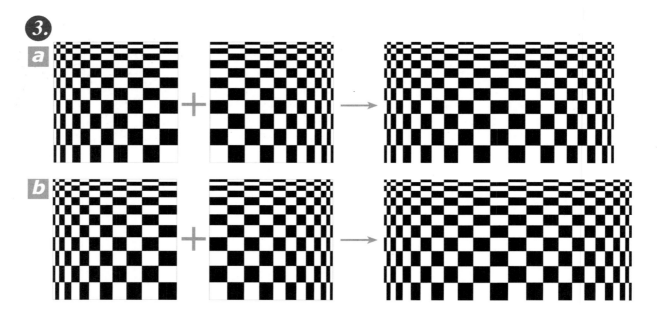

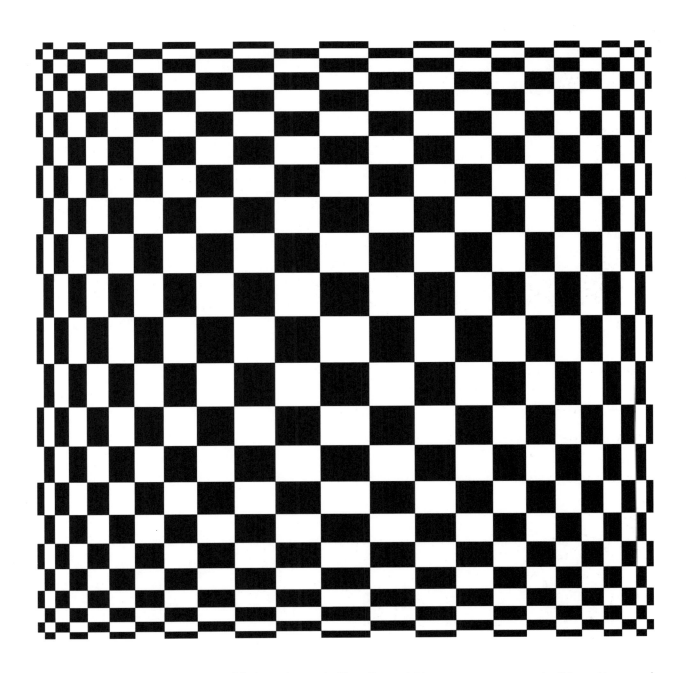

With the basic models assembled as shown in Figs. 3a and 3b, you can now create this pattern and experiment with other interesting designs.

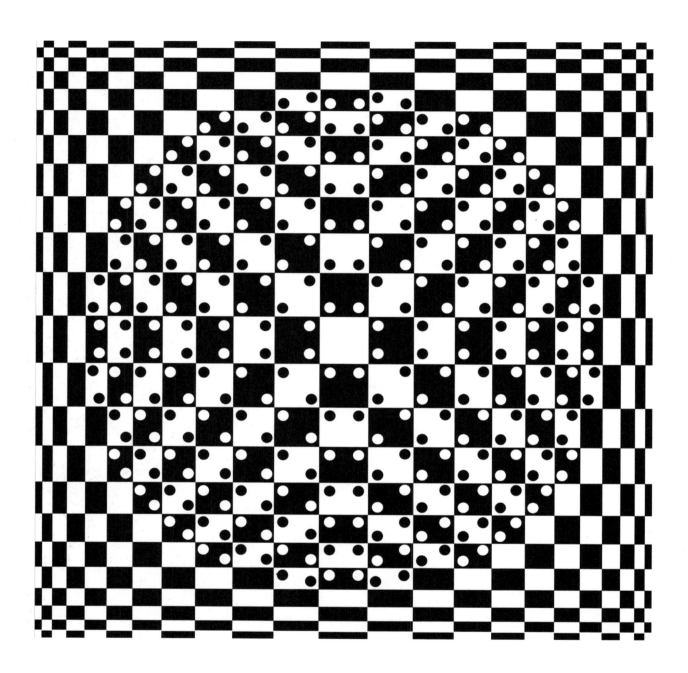

Adding pairs of dots in each cell as shown above enhances the circular appearance of the design.

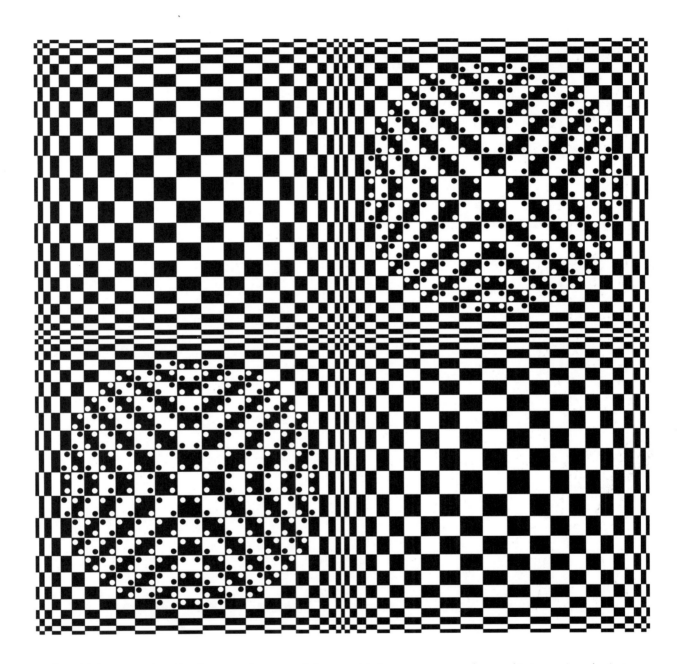

Combining together the two previous models, we obtain a more complex and interesting design.

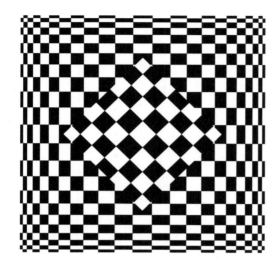

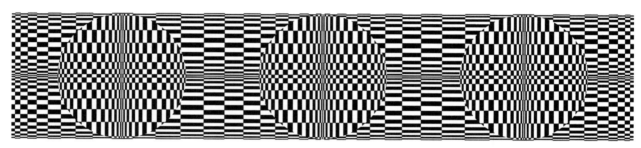

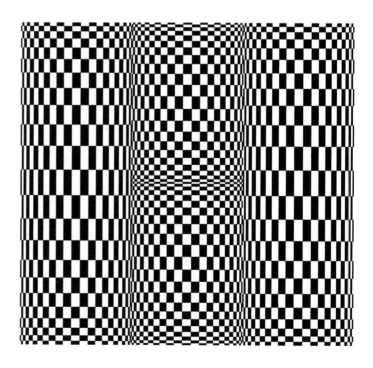

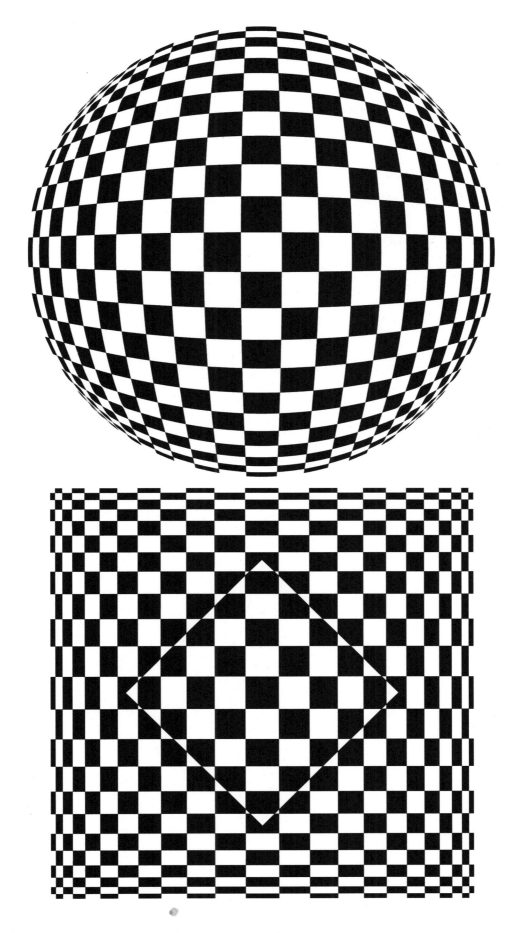

Following the step-by-step tutorial above, you can produce an intriguing pattern showing a diverging or converging virtual path.

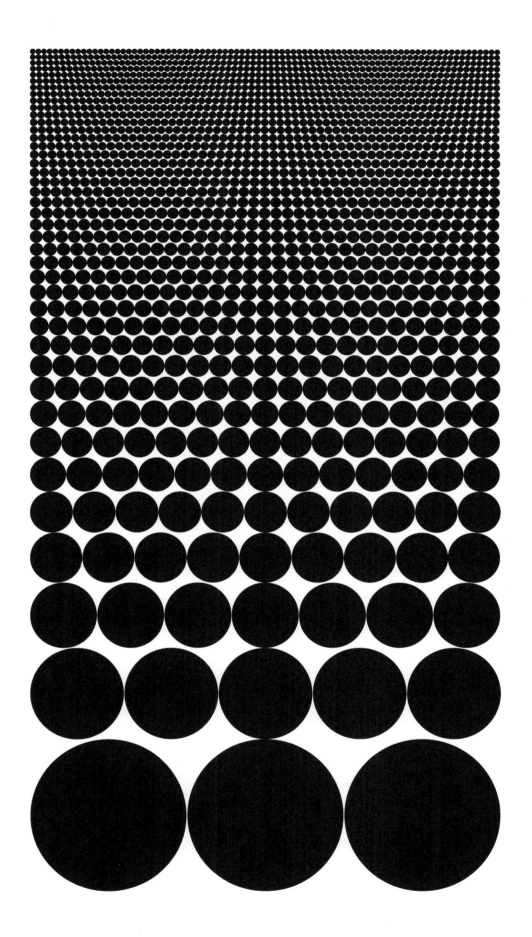

1.

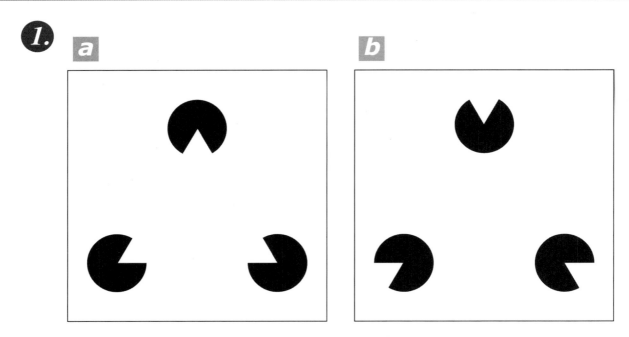

The Pac-Man shapes in Fig. 1a give an illusion of contours around a white triangle. When the Pac-Man shapes are rotated (Fig. 1b), the illusion disappears.

The illusion works even with a 3D perspective. In Fig. 2a the illusory lines of the square combined with the different shades of gray create the perception of a pyramid with a square base. Here too, when the Pac-Man shapes are rotated (Fig. 2b)—*pft!*—the depth effect disappears.

Scientists suppose that when we see an incomplete figure, our brain interprets the missing part as hidden by some objects. So, we can create even more complex figures using this principle. Such illusory or subject-contour effects are classed as "Kanisza illusions."

2.

Look for a copyright-free and eye-catching picture on the web, for instance an attractive woman in a bodysuit and high heels (Fig. 1a). You have then to outline its main features as shown in Fig. 1b. Next, draw a regular alignment of black dots (as seen in Fig. 2). Eventually, superimpose and adjust your silhouetted image over the alignment of dots and remove any trace of the contour. The subjective woman is complete! (See next page.) The strength of the illusion depends on how much you reveal: the less you reveal, the more the effect increases.

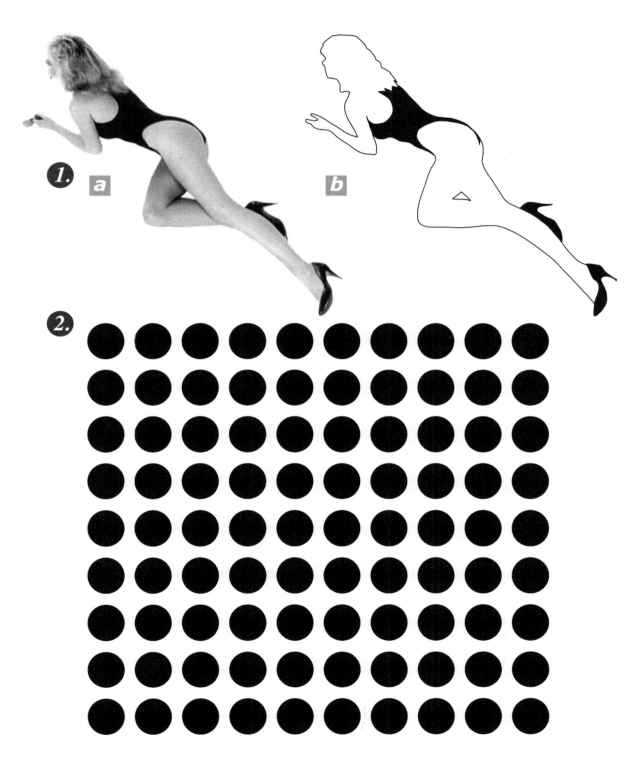

I bet many of you wish this pretty girl were really there. Sorry, it's just your imagination. In fact, your brain fills in the missing contours to create a coherent image.

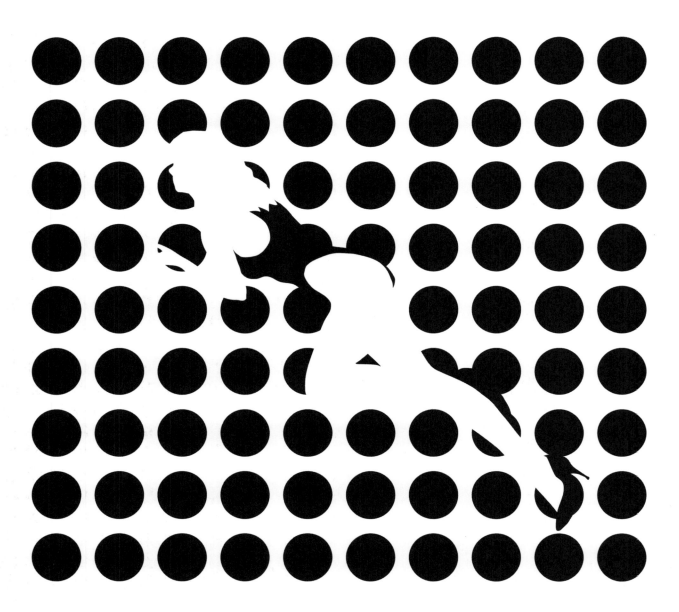

Below is another example of an outlined woman in a long, black dress (Fig. 1a). In this case, we will use a background pattern containing smaller dots but greater in number (Fig. 1b). Here too, we must superimpose and adjust the main silhouette over the pattern of dots, but in order to create a more dramatic effect the black dress is layered in "difference mode" (negative), so that the dots or portion of dots within the dress become white. You can see the final result on the next page.

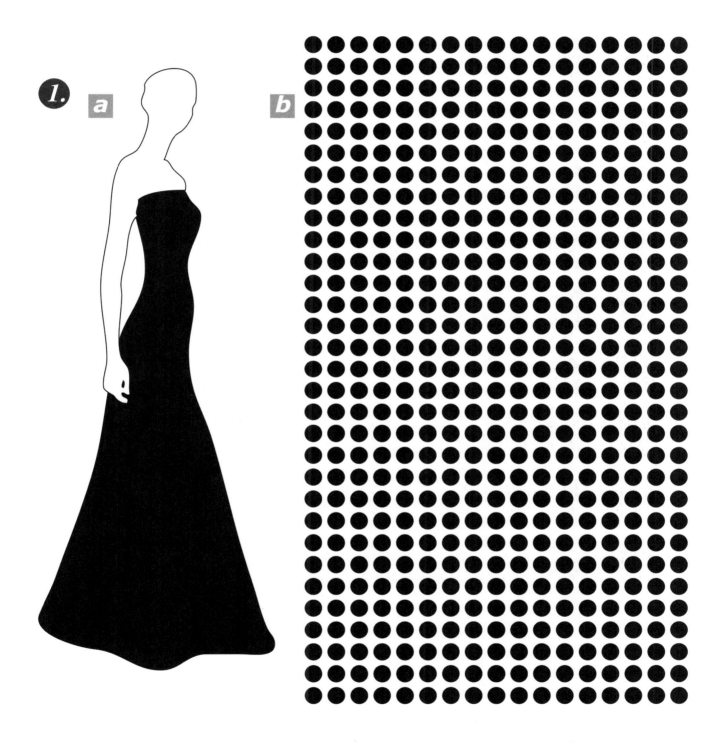

Following the easy technique described previously, you can try different visual experiments using even more complex shapes and outlines, such as a cat hunting a butterfly (Fig. 1a) or a pirate skull (Fig. 1b). You may also change the alignment disposition of the dots as shown in Fig. 2.

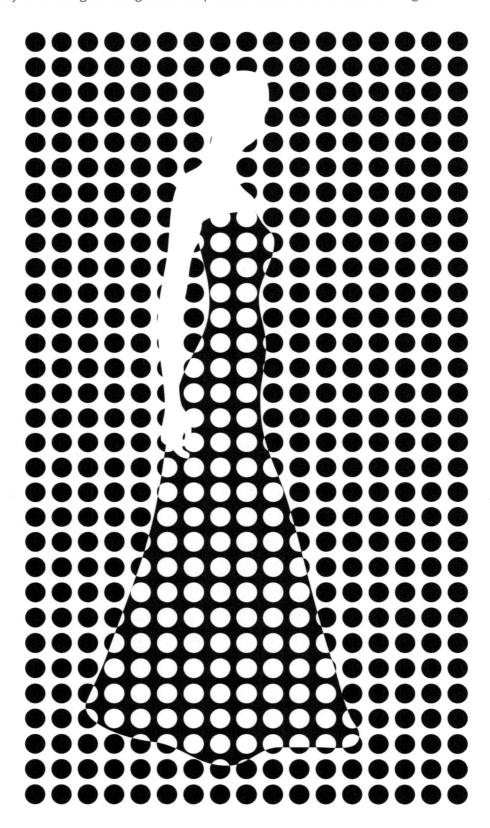

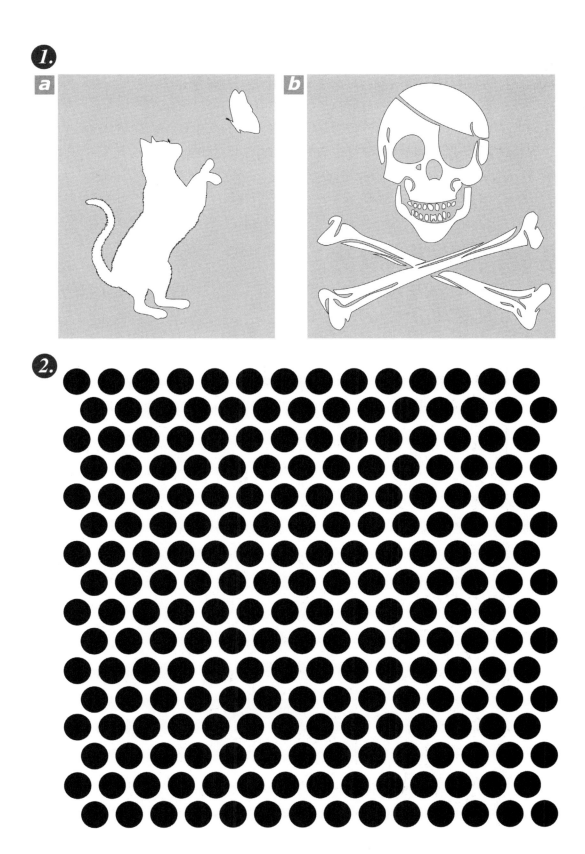

In the following pages you can see different visual examples. For instance, instead of black dots you may also use white dots and a black background; you can layer the main image in "difference mode" (negative) too.

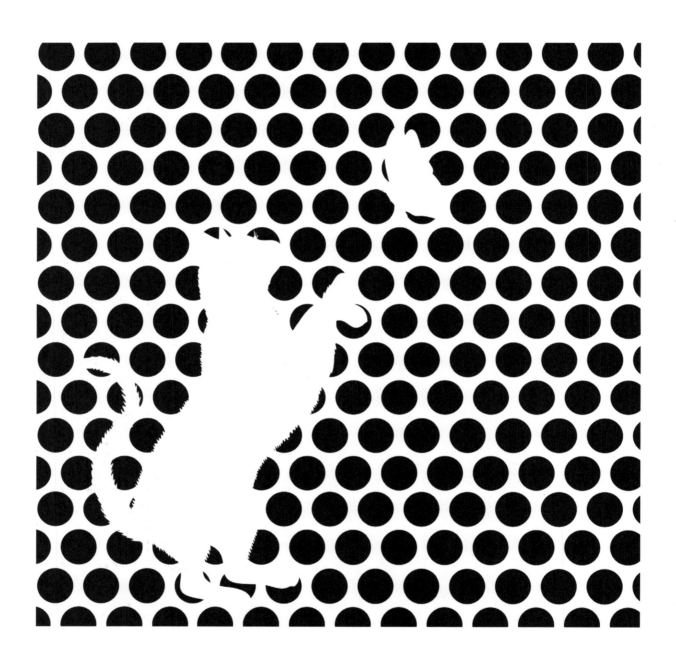

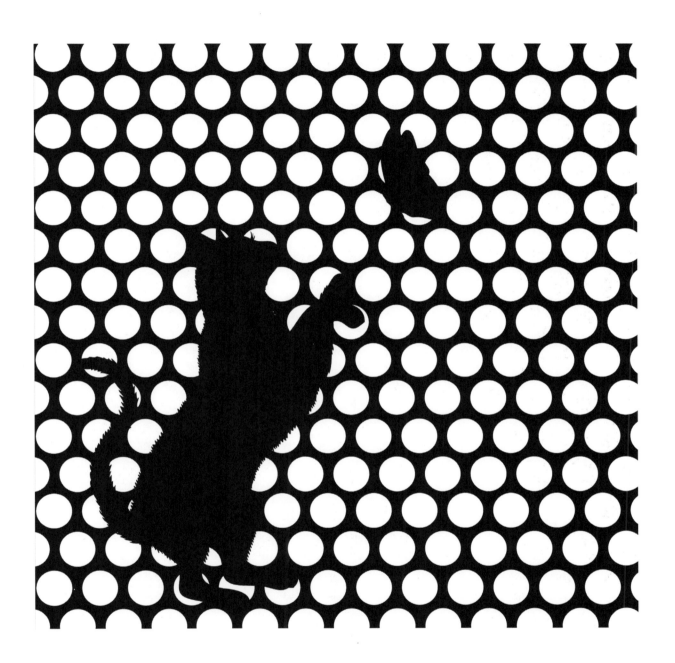

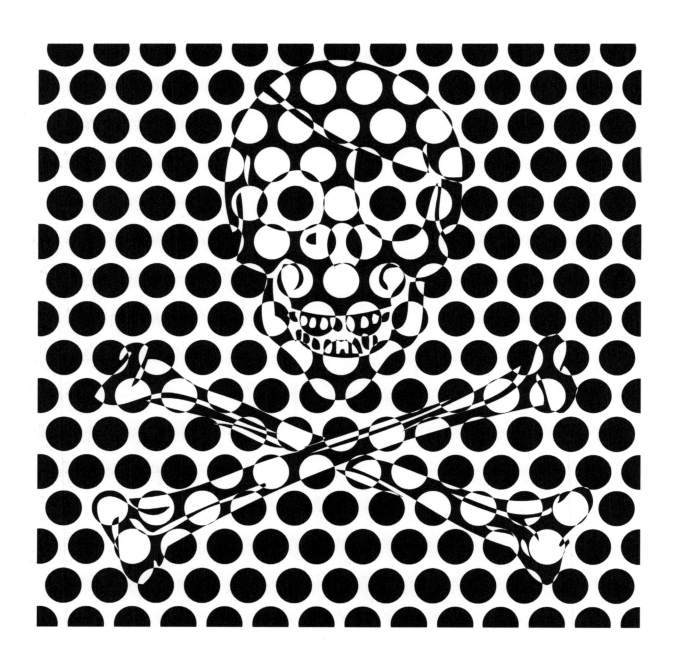

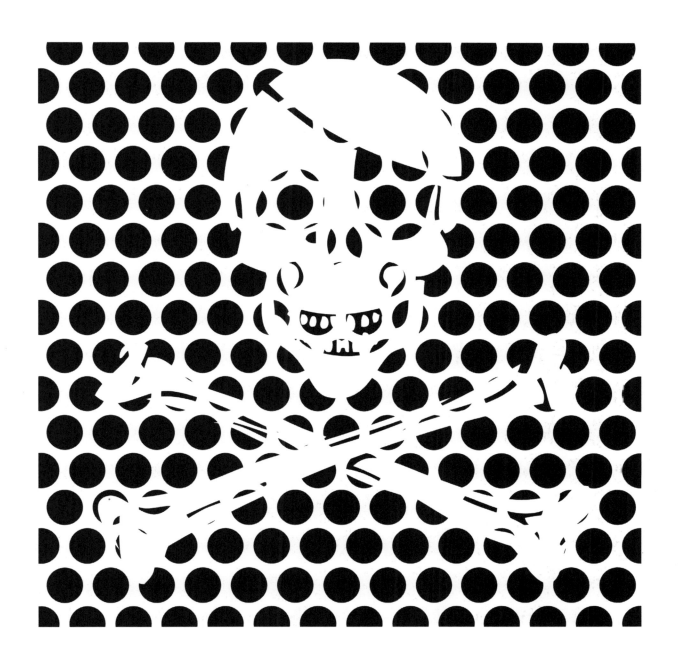

NEON SPREAD, OR THE GLOWING EFFECT

1.

a

b

c

If you were asked to describe Figs. 1a and 1b to the left, you would probably answer that in the first figure you see four blotches and, in the second one, a white square covering the blotches. The problem is that the square does not exist because its borders are incomplete.

The next image, Fig. 1c, is another way of showing the square. What you perceive now is a kind of tinted square placed over the four blotches. The sense of a tinted material is so strong that the lighter gray parts seem to diffuse out and slightly tint the empty space between the corners. Though this translucent square with complete borders separating it from the white paper doesn't exist at all, you can't stop seeing it.

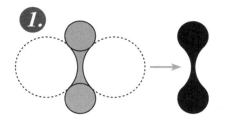

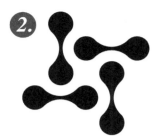

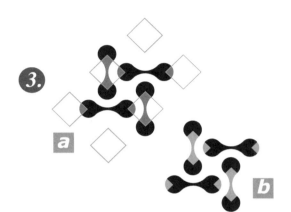

Following the simple instructions from 1 to 3 here, you can create an 8-shaped object that will be used to construct an interesting pattern. Fig. 2 depicts the spatial distribution of the tiles. Fig. 3 shows how to crop series of squares into the basic pattern (a) and color the cropped elements in soft gray (b).

Once all basic patterns have been put together following the visual directions shown here, you will perceive oblique alignments of squares (that do not exist). Moreover, the illusory glowing squares seem to pulse slightly when you concentrate on the image!

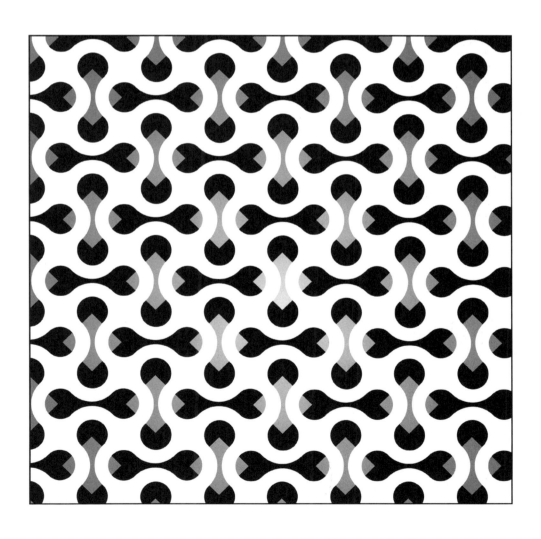

Ambiguous Figures

Ground is often thought of as background or negative space—an empty non-form that gives shape to the figure. In painting, "figure-ground" refers to the relationship between an object and its surroundings. Sometimes the relationship is stable: it is easy to pick out the object, or figure, from the ground. Other times the relationship is unstable, meaning it is difficult to distinguish the figure from the ground. Occasionally the relationship is ambiguous, meaning that the figure could be the ground (and vice-versa), or hidden in the background.

Figure-ground illusions swap the main figure and its background, while "multipart figures"—composed of several distinct figures—swap portions of bodies, limbs and heads from one figure to another. In the following pages we will study some interesting aspects of these kinds of illusions.

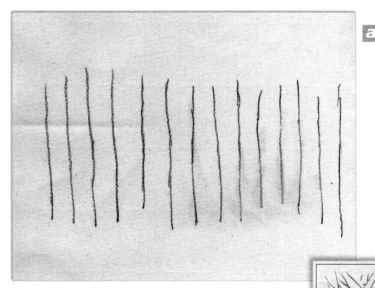

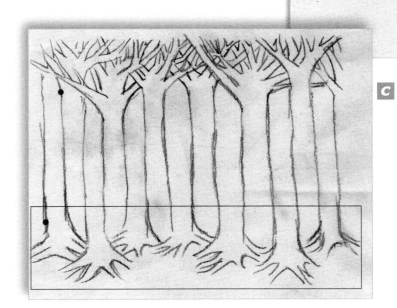

a Draw with a soft pencil a series of uniformly spaced vertical lines, as shown in Fig. a. These basic lines represent the trunks of forest trees. We will, using those lines as starting points, sketch now the branches of the trees. As you can see in the example of Fig. b below, each tree is separated from the next by a blank space.

Then sketch the apparent roots of the trees, but starting one line ahead of the first vertical line that profiles the branches. The two distinct points connecting the branches and the roots to the vertical lines are highlighted in Fig. c with gray dots. Notice that the roots also are separated from one another by blank spaces.

b

c

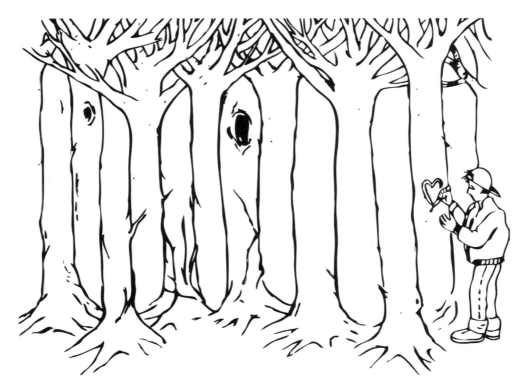

Eventually add extra elements in order to make the illusion more deceptive (I have added to my example fake tree holes and a young boy carving a heart on a tree trunk; see figure above) and finish your sketch in black ink. You can use either a pigment pen or a brush for this purpose.

To strengthen the illusion effect, add color to your drawing, paying attention to gently shade the transition part of the picture where "figure" and "ground" merge (see figure to the right). Do not hesitate to try different media or art styles to meet your expected visual effects.

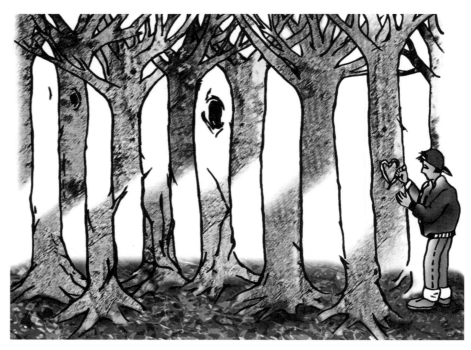

Below is a more complex image using the same principle.

There is an old Indian story about seven blind men deciding what an elephant looked like. The first man felt the elephant's ear and said, "The elephant is a large leaf."

The second one took hold of the leg and maintained, "No, the elephant is a tree trunk!"

The third man had the tail and said, "Maybe the elephant is a thick rope."

The fourth man touched the body and said, "The elephant is a wall."

The fifth fellow held the trunk and countered, "No, the elephant is a snake!"

The sixth man put his hand in the elephant's mouth and declared, "The elephant is just a bag."

The seventh man felt the tusk and said, "The elephant is a spear."

All of them were right, in a way, but none of them had the correct picture of an elephant! This story is used to demonstrate either the relative and inexpressible nature of truth, or the subjectivity of perception. In fact, the whole is always essentially different from the sum of its parts.

This transition story is of help to introduce the next visual illusion . . .

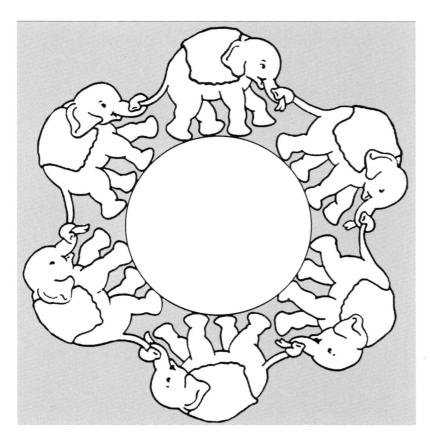

I saw in a children's booklet an amusing illustration of six little elephants, each holding its counterpart's tail with its trunk, while rolling on a large ball. Why not convert this simple illustration into an amazing optical illusion? Reproduce first, with a soft pencil, any of the elephants from the illustration, paying attention to draw evenly spaced legs, as shown in Fig. a.

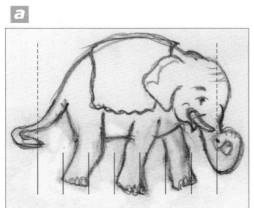

Then erase the feet of the elephants and draw them again within the legs' interspaces; the example in Fig. b provides a more precise visual indication of what you have to do. Ink the final result, and make six photocopies of the drawing. At this time, arrange and stick the cut-outs of the elephants around a circle, with the trunks and the tails interlaced, and reproduce the layout with the help of a light-box (or with tracing paper).

To finish your work, ink and color the reproduction with your preferred art media and technique; the example below gives a good idea of how it should look. Notice that the part where the bodies and the feet of the elephants are mixed up is bleached.

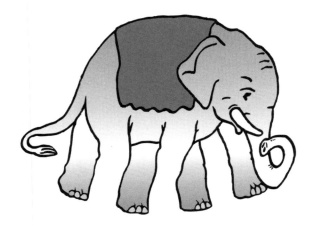

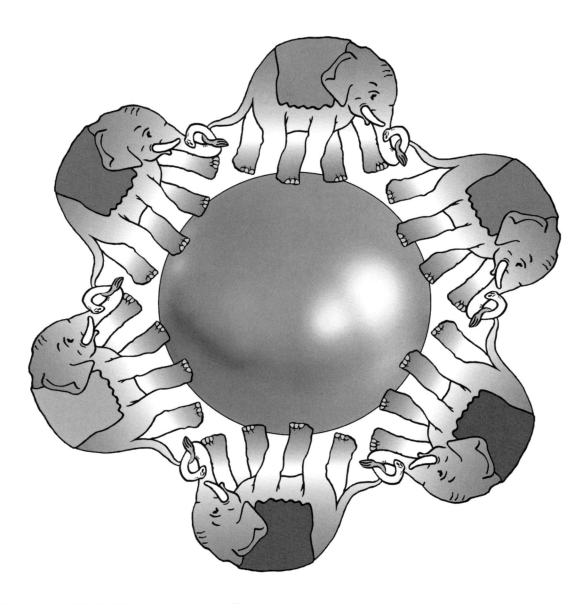

MAGIC LIZARDS

1.

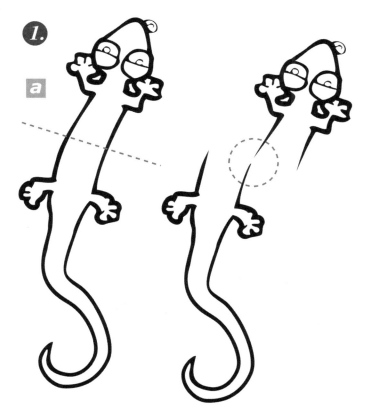

a

Shifting the upper outlines of a drawn figure forward from its lower outlines (known as a "figure with discontinuous boundaries") always leads to visual confusion.

To create another simple yet effective ambiguous figure involving a figure-ground perceptual reversal, first sketch an animal with a long trunk and trace the outline of its main features with a pigment pen, a marker or even a brush (in our example: a funny lizard). You can use a light-box for this purpose or, if you do not have one, simply place the paper against a window so that it is backlit.

At this point, cut the outline of the animal in half horizontally and recompose the image by shifting a part of it until at least two lines of the composition meet in a straight line (Fig. 1a). The final overall outline of the drawing should appear seamless, and you will use it as a pattern from which to make several variants. You can reproduce the motif by varying the direction and the number of repeats (Fig. 1b).

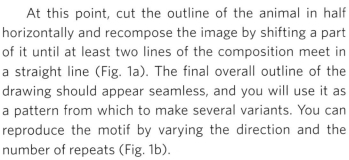

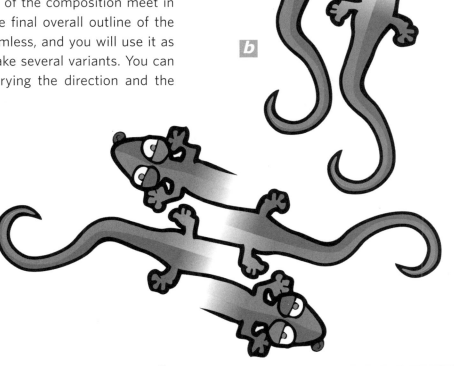

b

When you are satisfied with your drawing, color it slightly to strengthen the illusion effect, using any medium and style you like, such as watercolors or ink; you may also rework your image on Photoshop.

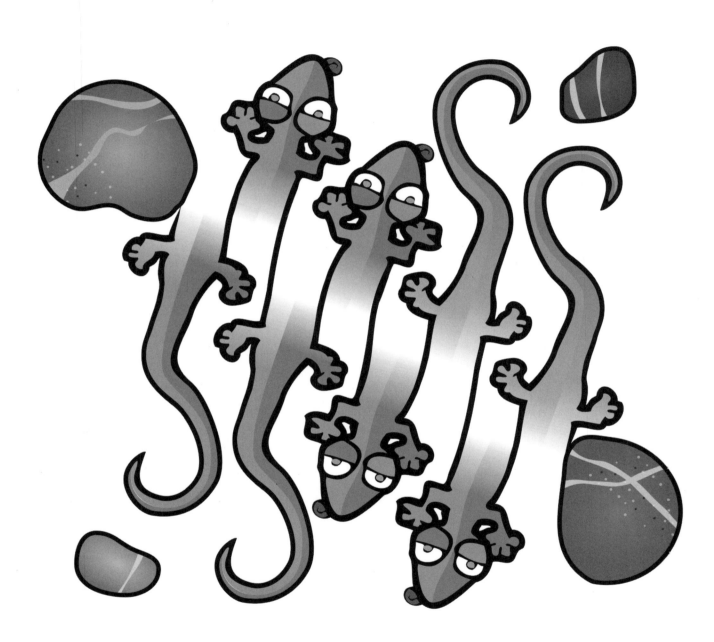

Below is a more complex image involving a figure-ground perceptual reversal.

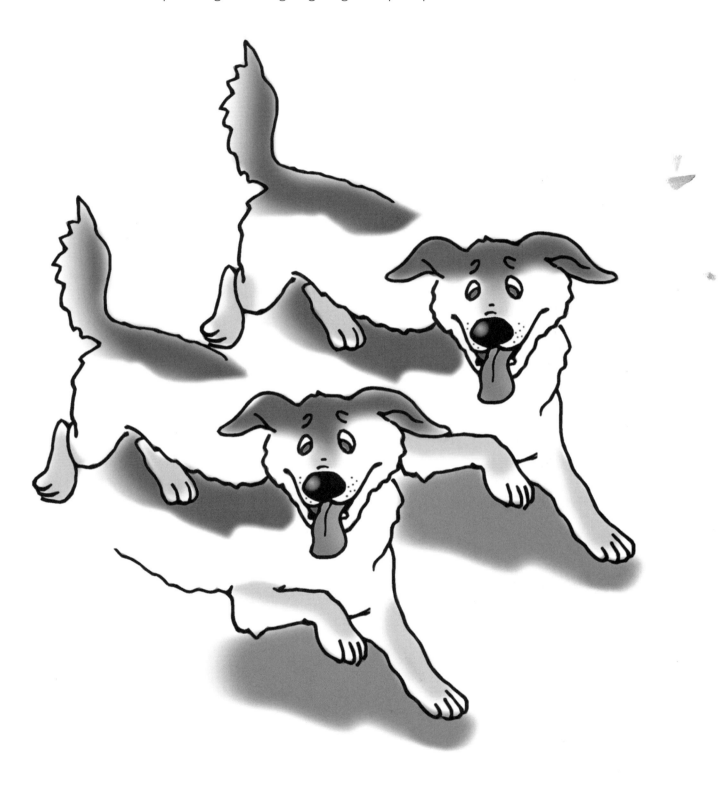

Here is an interesting variant of a figure-ground perceptual reversal, which involves alternating black-and-white elements.

Draw two simple subjects such as two hands (Fig. 1). Then lay them together in a circular arc as shown in Fig. 2. Darken the arc-like shape and use this drawing as a model.

Then make five reproductions of the model and arrange them symmetrically in a linked circle. Try various other combinations too and see what you can make from them. Finally, fill the central blank of the design with black and use your creativity and imagination to decorate this unused space with suggestive elements. I am sure that the two variants in the following pages will inspire you!

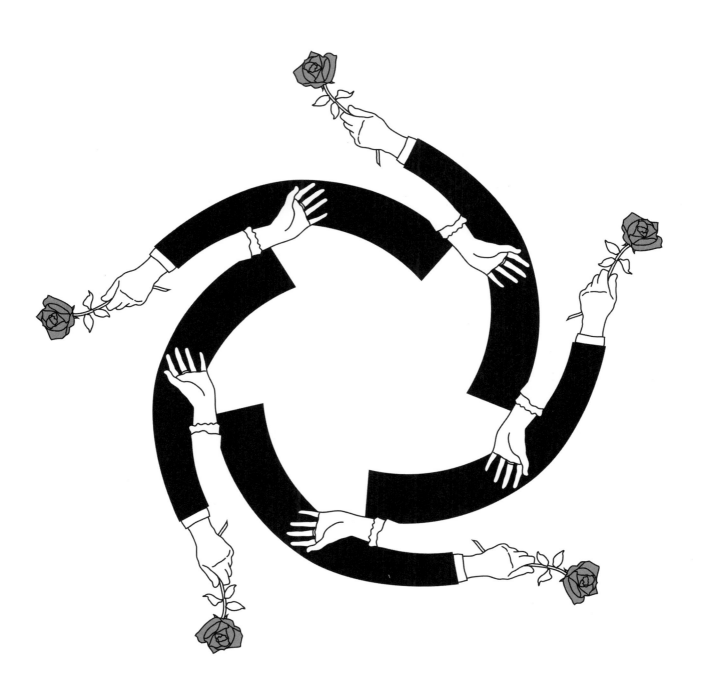

CONFUSING BABIES

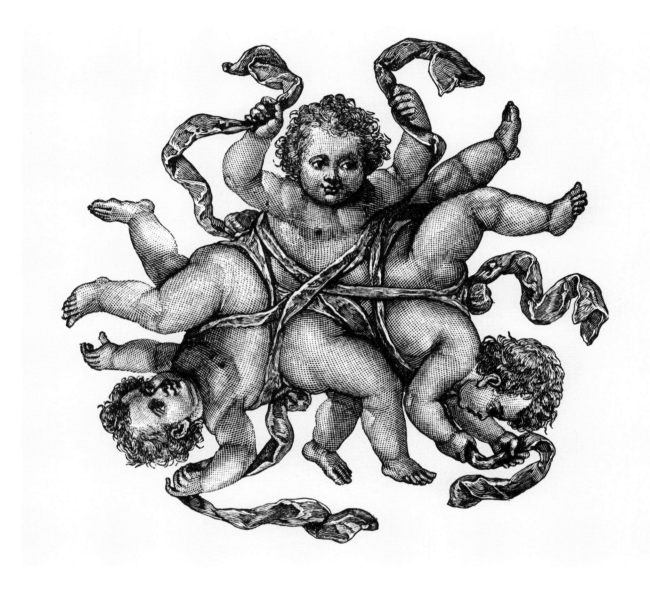

Mythological creatures with overlapping or interchangeable bodies, heads and limbs were popula᠊ in Middle Ages iconography. The overlapping body parts symbolize the transition states or cycles by which inner potential becomes the actual sequence of events, while the static elements (generally heads) are a metaphor for constancy amid change. In the Renaissance example above you can see three babies' heads with seven possible distinct bodies.

In this experiment you will bring the spirit of this old print of multipart babies up to date. First of all, you need to adapt the faces. Find some baby portraits (Fig. 1) that are suitable for use in the redrawing process of the illusion.

With a soft pencil, reproduce the original picture but replace the heads with the current ones (Fig. 2).

Ink over the sketch, rub out any pencil marks and make several photocopies of your artwork.

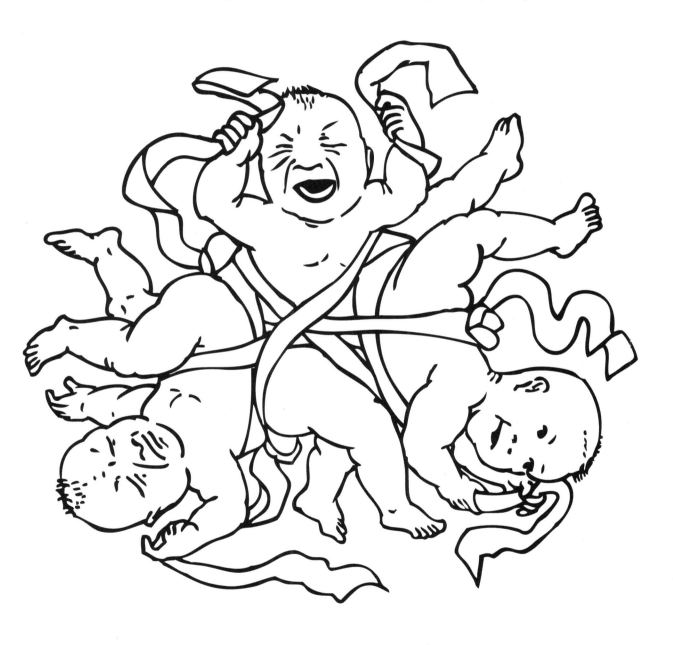

The photocopies will allow you to try several color variations, as you can see in the examples. Shading is important to give volume to the figures and emphasize the feeling of oddity.

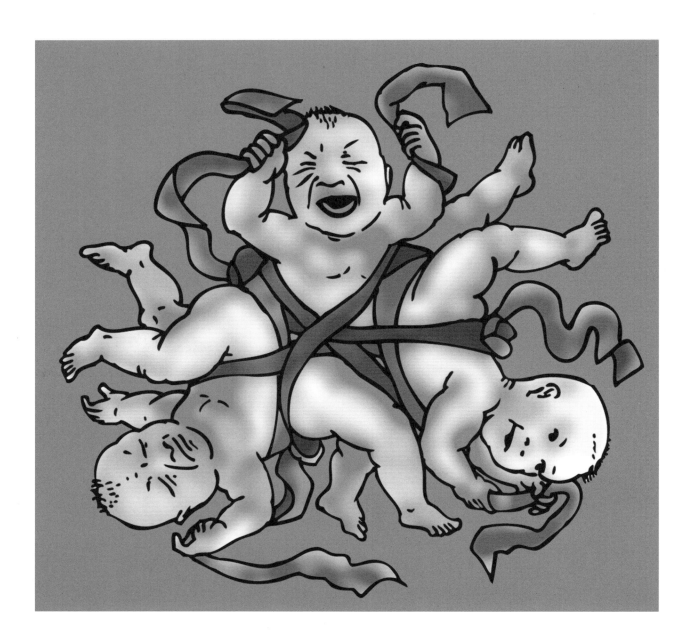

You can see in the figures below the visual proof that three heads are actually shared by no fewer than seven distinct bodies.

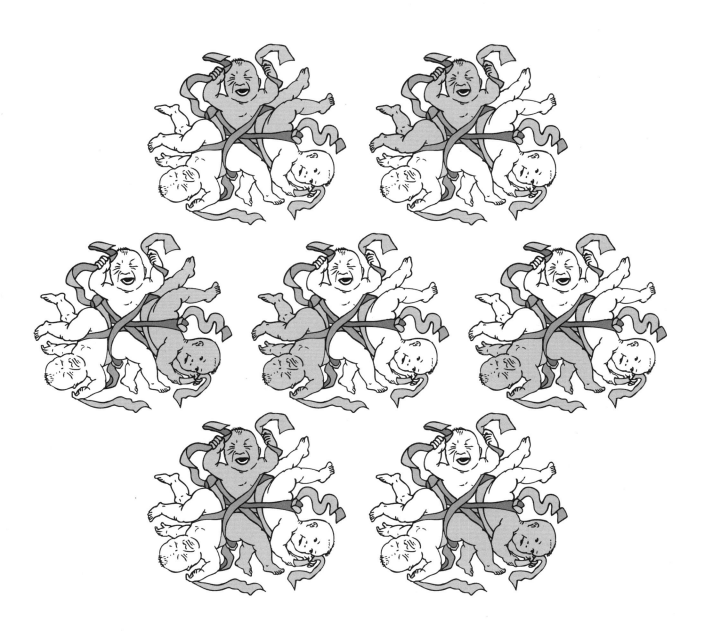

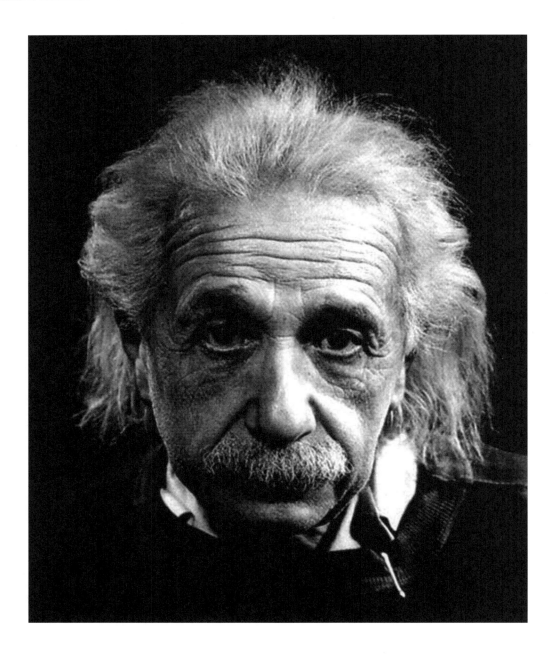

Some ambiguous or bistable figures are "two pictures in one"—looking at them one way, we see one thing, but looking at them in another way, we may see something else. *"Figure-ground illusions"* are the best-known ambiguous figure cases where one image is often hidden or suggested in a "host" image.

In a figure-ground illusion there is often an "induced" apparent image that visually tends to the "inducing" hidden image. Obviously, for the illusion to work, the induced and inducing images should share some common spatial properties or features.

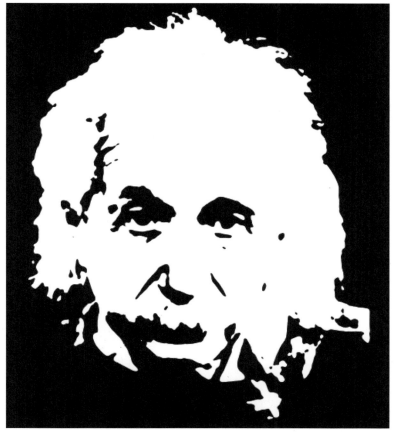

In this exercise, we are going to hide the portrait of the famous mathematician Albert Einstein within an everyday scene. First convert a gray-scale portrait of the scientist to a high-contrast, black-and-white image; you can use tracing paper, a light-box or even Photoshop for this purpose.

Reproduce then only the facial features with a soft pencil (highlighted in gray in the example), blurring them slightly. Now you will draw over the "inducing image" an apparent "induced image."

I immediately saw that the outlines of two baseball caps could fit the shape of Einstein's eyes. By association of ideas I finally drew a couple of young people eating popcorn on a mat. As you can see, the blurred dark details of Einstein's face are compatible with the outlines of the individuals.

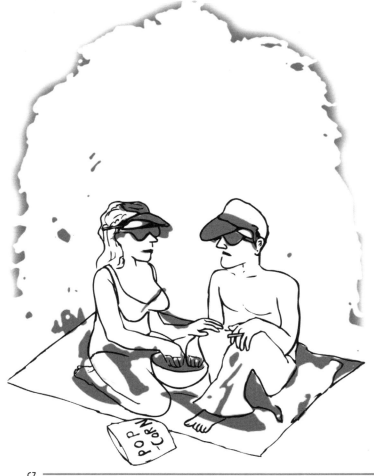

You can now ink the scene with a pigment pen and try different color-filling techniques (see examples on the following pages). The evocative title of our artwork could be: "The immanent presence of Dr. Einstein."

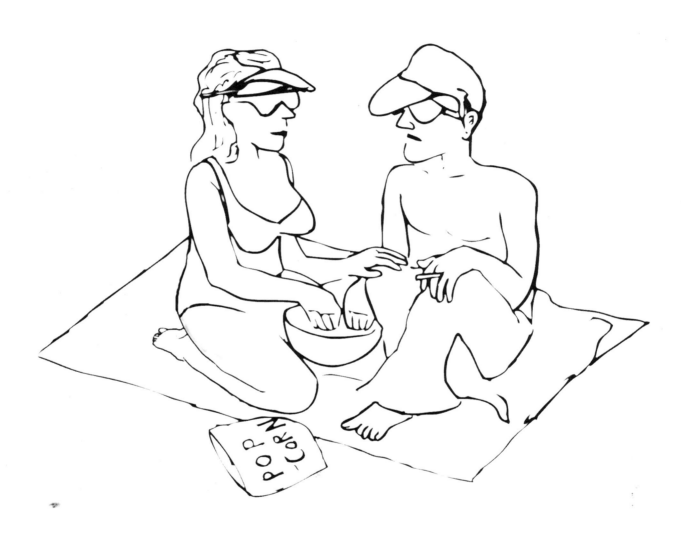

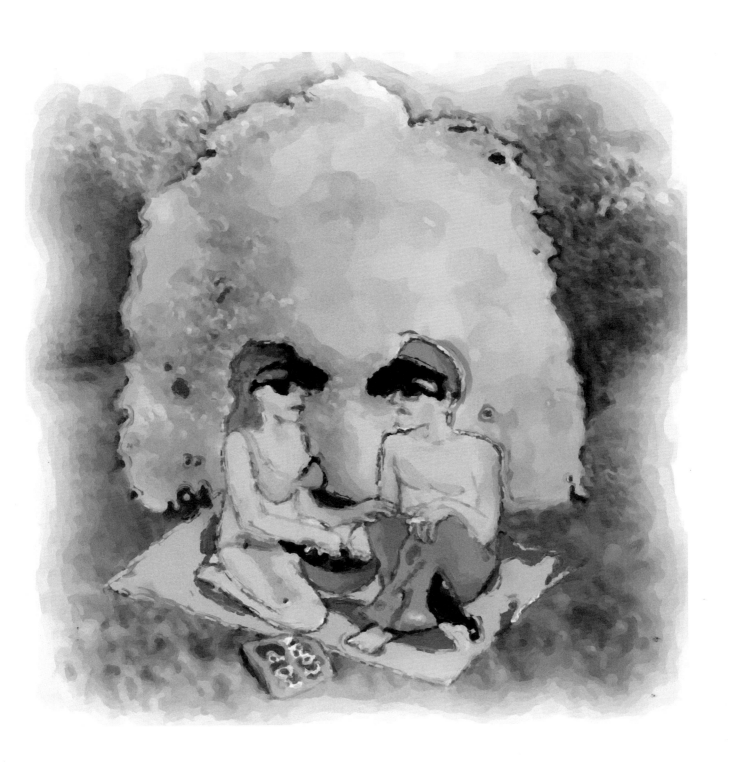

A gray-scale pencil rendering.

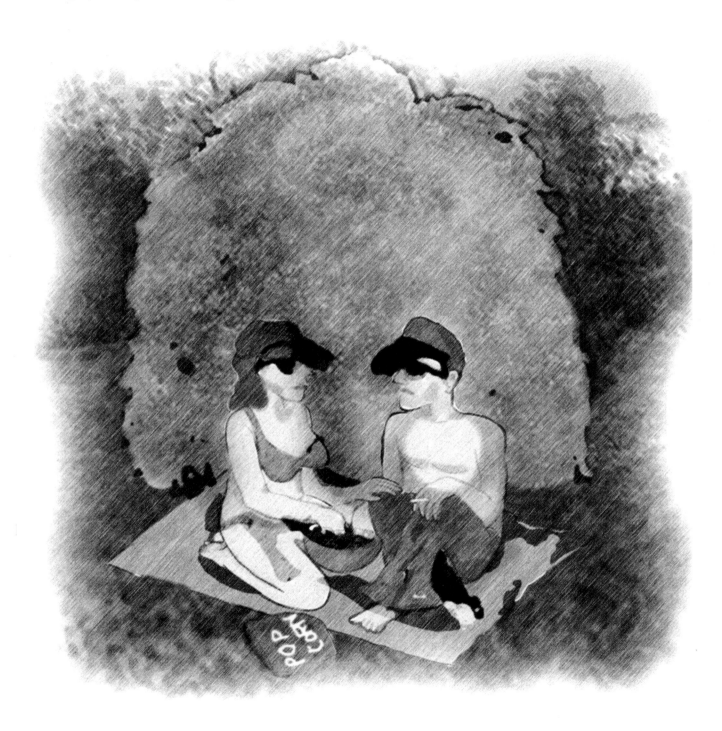

Hidden or Suggested Figures Within Camouflages

In this chapter we will play hide-and-seek with camouflages. You certainly know that camouflage is a visual "noise" usually made from line or dot patterns that enables living beings to blend in with their surroundings. Well, in a set of lines or spots it is also possible to encrypt enough information to make a figure appear under certain circumstances. The figure is there, partially hidden, but you have to mentally organize parts of the camouflage into a meaningful pattern in order to see it!

And once you understand what is being presented, your perception changes; it becomes impossible for you to focus on only the apparent figure without paying attention to the hidden image.

I will show you in the following pages some basic techniques to create such intriguing optical illusions.

1.

The simplest way to create an encrypted image is first to create an arrangement of vertical code-bar-like stripes as shown in Fig. 1a. Then, use Google to search for a black-and-white copyright-free picture on the web that will inspire you. In the example is a picture of an attractive young woman (Fig. 1b).

Using Photoshop, overlay the main picture on the grid of vertical stripes (Fig. 2) and reduce the luminosity of the background image up to 15 percent (Fig. 3). You will obtain an intriguing code-bar containing a subliminal image that becomes perfectly visible when you move it from side to side!

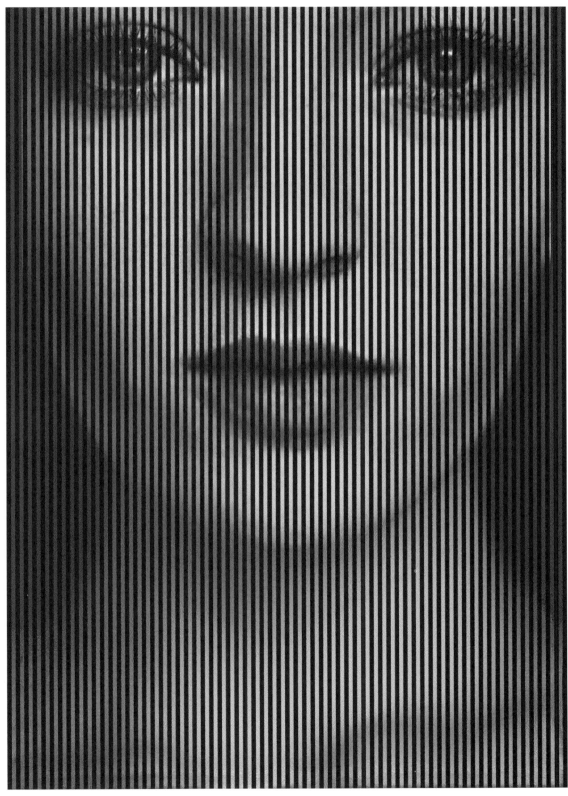

With the same technique I concocted this intriguing variant. Can you guess who is hidden within the stripes?

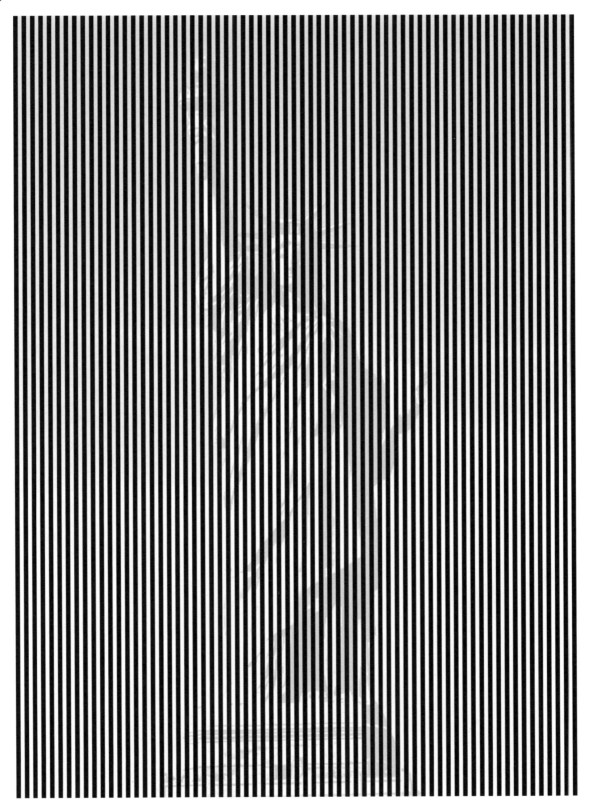

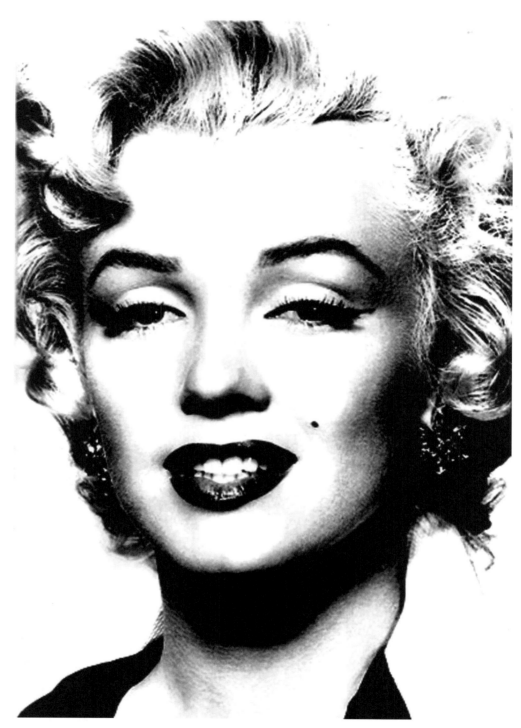

To create this kind of Op Art illusion you first have to select an iconic character such as Marilyn Monroe. You do not need a high-resolution reproduction to achieve the visual effect. What is important is that the picture has strong black-and-white contrasts.

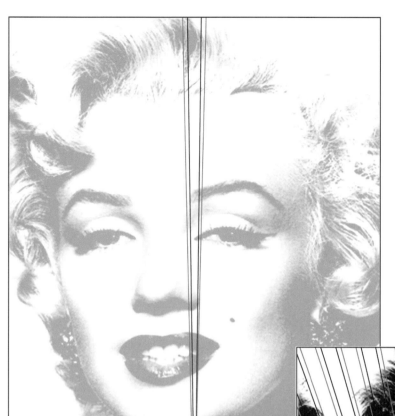

1.

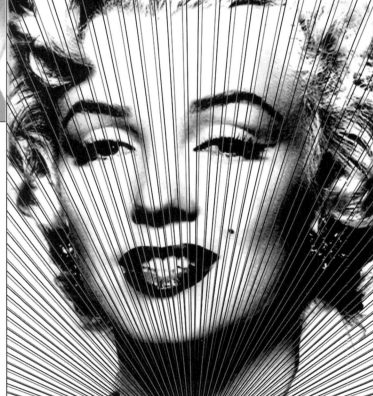

2.

From a central point, slice the picture with two series of radial straight lines (Fig. 2). In Fig. 1, you can see the starting set of two gray rays enclosing two black rays. The two gray rays are slightly larger and meet at an angle of two degrees, while the black rays meet at an angle of only one degree.

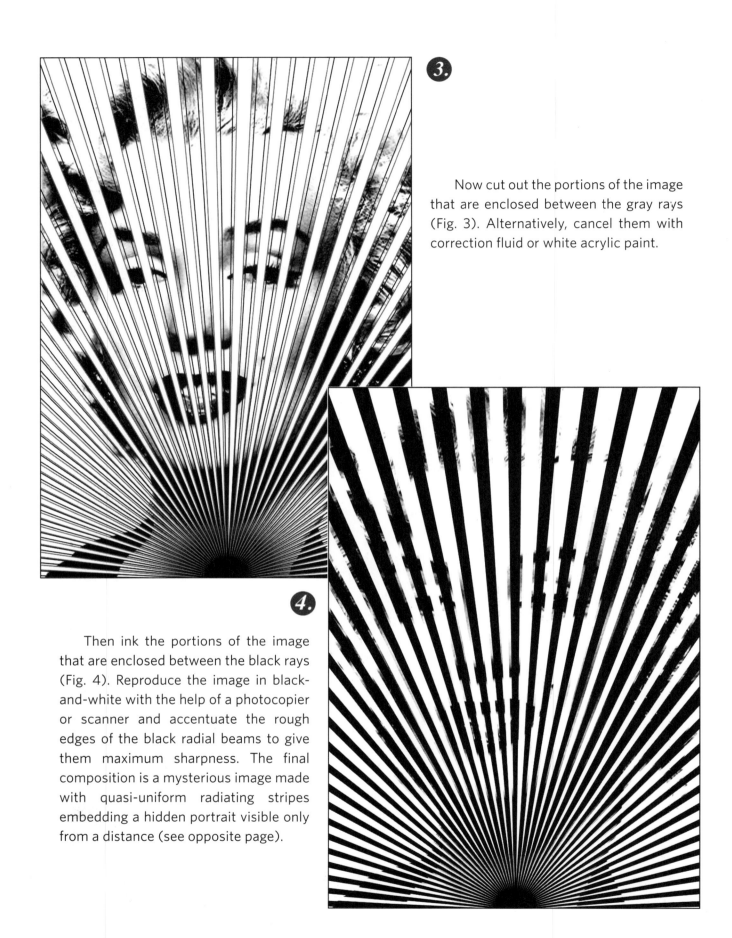

3.

Now cut out the portions of the image that are enclosed between the gray rays (Fig. 3). Alternatively, cancel them with correction fluid or white acrylic paint.

4.

Then ink the portions of the image that are enclosed between the black rays (Fig. 4). Reproduce the image in black-and-white with the help of a photocopier or scanner and accentuate the rough edges of the black radial beams to give them maximum sharpness. The final composition is a mysterious image made with quasi-uniform radiating stripes embedding a hidden portrait visible only from a distance (see opposite page).

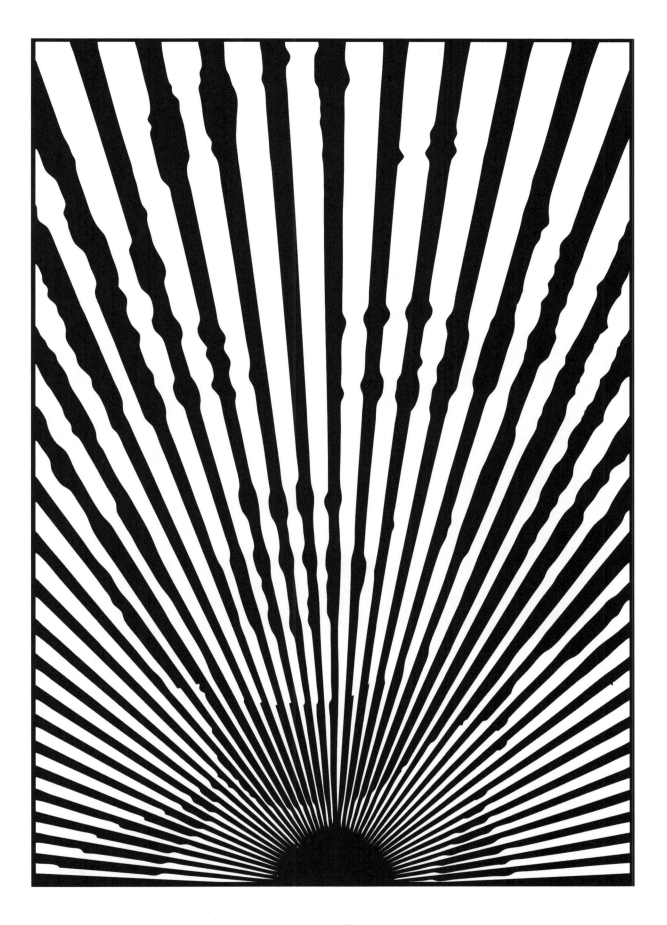

To add color, you can paint the black-and-white stripes with gouache or acrylic paint. Or you can scan the black-and-white model and use Photoshop to color it or add more visual elements.

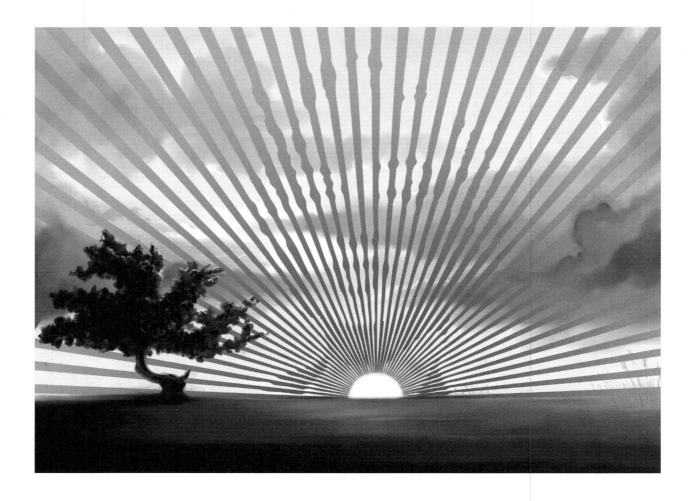

You could also use your design to make an impressive T-shirt presentation and sell your work through these online retailers of stock and user-customized on-demand products: *Redbubble.com, FineArtAmerica.com or CafePress.com.*

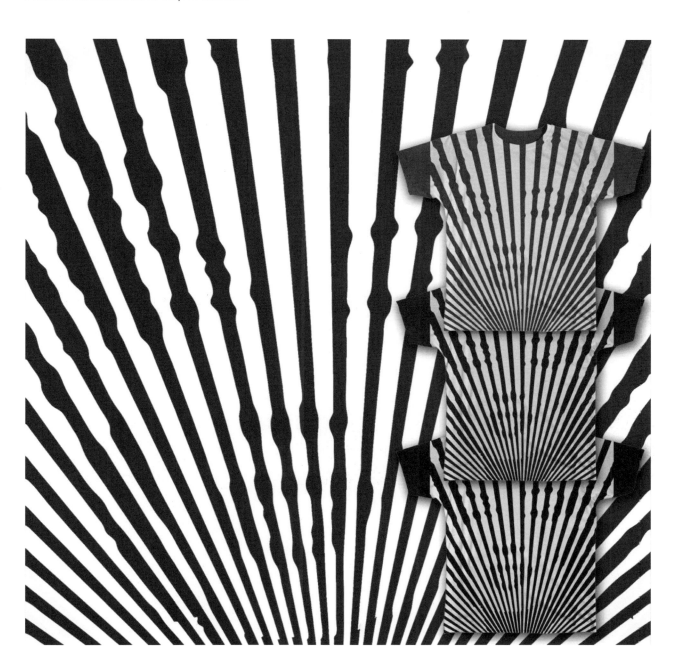

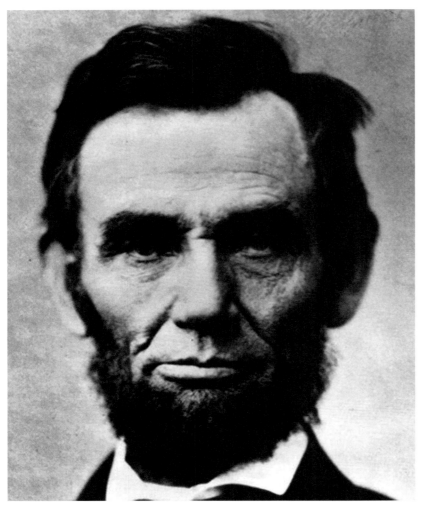

It is also possible to hide faces in a regular arrangement of dots. Here too you have to select a *very* famous face as raw visual material to make the illusion work. This is because the optical information of such iconic art may be so bare-bones that even our expectation—based on our personal cultural background—may not be of help in discriminating whose face it is, unless that face is anchored in our collective memory. Thus, a universally known face, even simplified to the extreme, is always recognizable. For instance, the rough self-portrait below is unequivocal to any lover of cult cinema!

We will then use for our tutorial the famous black-and-white portrait of Abraham Lincoln (seen above).

Draw on the portrait a set of orthogonal discs. As you can see in the example, each basic set is composed of two circles: a black one inside a larger gray one. If you want, you can scan the original image and perform this process with vector software.

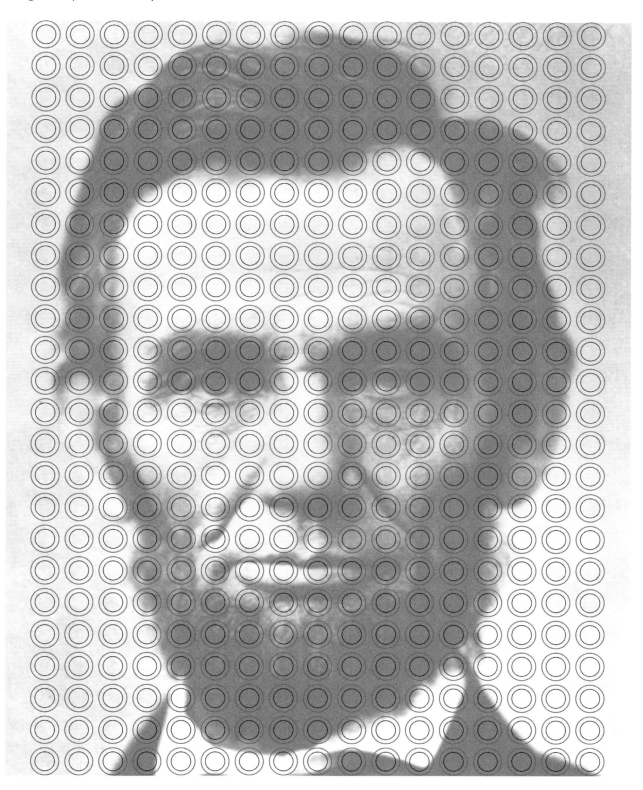

Once the pattern of discs is distributed all over the portrait, blacken the inner discs as shown below and cut or cancel the portion of the portrait outside the gray discs (see figure on opposite page).

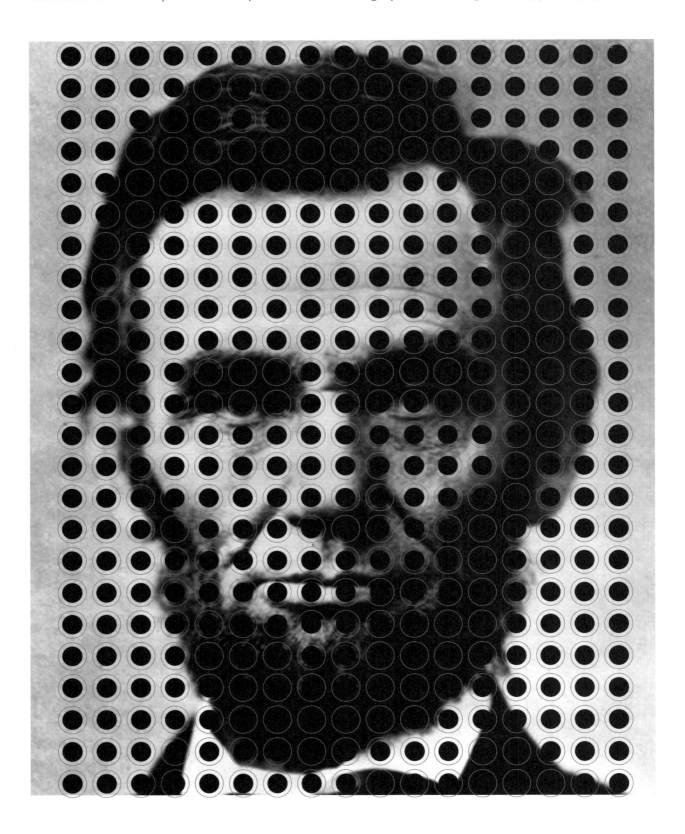

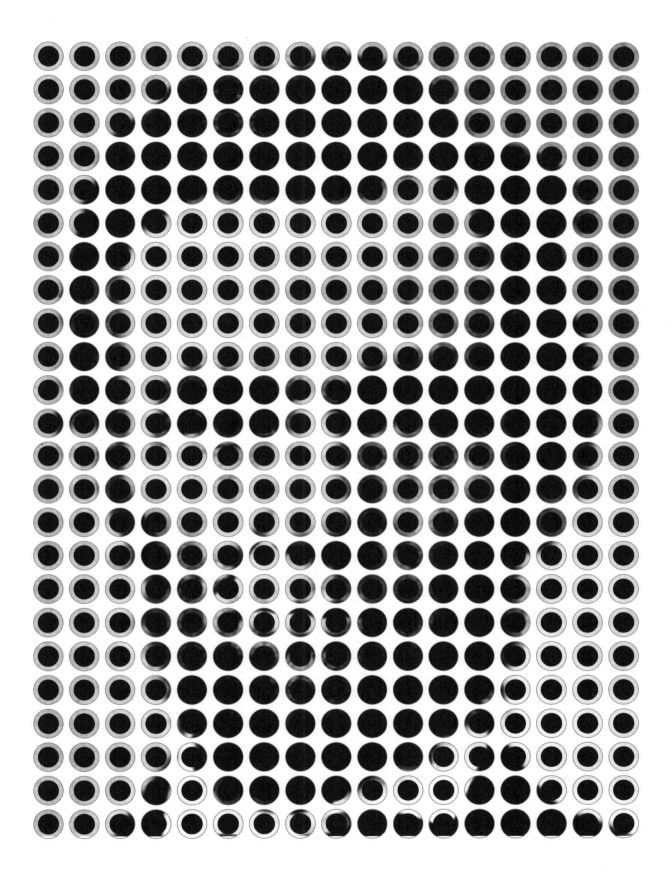

To conclude, reproduce the image in black and white, and accent or smooth the rough edges of the black orthogonal discs to give them maximum sharpness. The final composition should look like a collection of dots—some quite altered—that will reveal Lincoln's face if viewed from a distance. You can even color the background or apply some anamorphic transformation to refine your artwork.

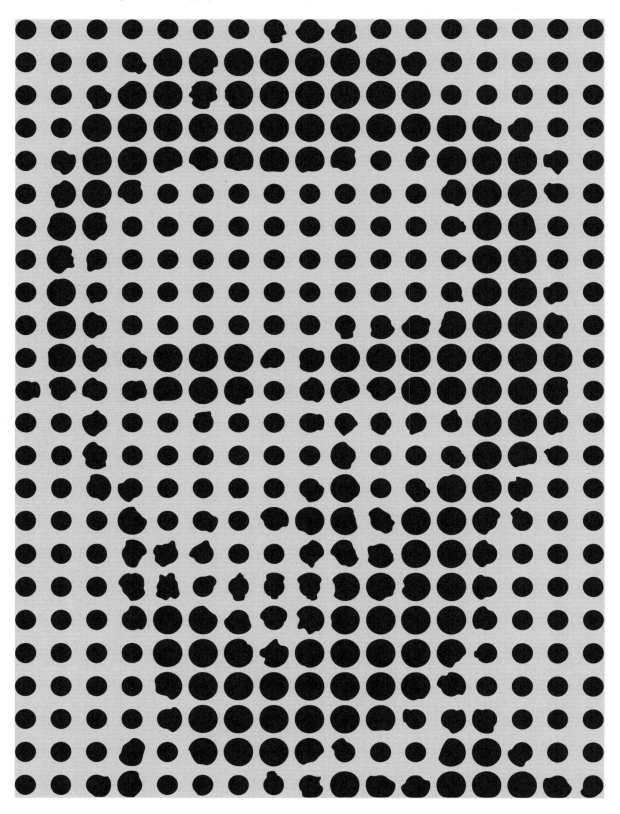

DOMINO FACES

Next, let us create some puzzling domino portraits by means of a mosaic-tiling technique. A domino portrait is simply a rendering of an image based on a given number of sets of dominos. To create it, you can start with any image—called the "target image"—such as a picture of Marilyn Monroe, John Lennon, Angelina Jolie or even your favorite pet, and a certain number of complete sets of dominoes. The goal is to position the dominoes in such a way that, when seen from a distance, the assemblage looks like the target image.

To find optimal positions for the dominoes, it is not necessary to make complicated designs or calculations. You just need one of two very simple software packages: MacOsaiX (Mac, http://www. macosaix.net) or Ezmosaic (Win, http://www.ezmosaic.com). Those applications make the creation of high-resolution mosaics easy by applying a mathematical technique known as "integer programming." Long used in operations research, integer programming has aided a variety of large-scale planning tasks.

First, use your drawing software to create thirteen different pictures of single black squares, each containing one to nine white pips, as shown below. Save these images in jpg or tif format in an archive called "image source." It is important that those different pictures are all the same size.

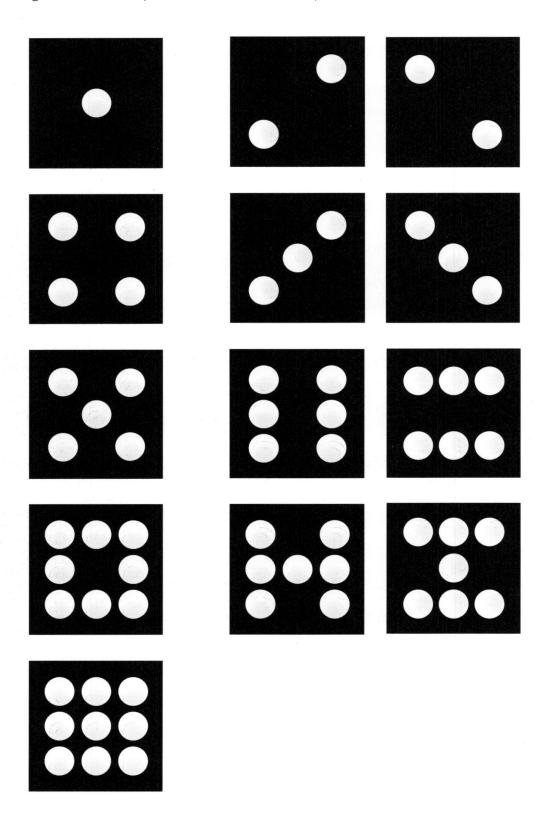

The procedure to create your domino mosaic is as follows:

1. Open your mosaic application (MacOsaiX or Ezmosaic).

2. Determine the target image you want to turn into a domino mosaic (here, a portrait of Angelina Jolie).

3. Choose the folder with the image source for filling in the tiles (where the thirteen images of dotted squares are archived).

4. Click "Start" and the application will begin creating your domino portrait for you. Below an interesting rendering of Angelina Jolie is created out of double-nine dominoes.

You can also use both black dominoes with white pips and white dominoes with black pips to achieve different effects in your artwork.

Here is another amusing "dominoed" subject (a cat called Domino—sic!) done with the previous method.

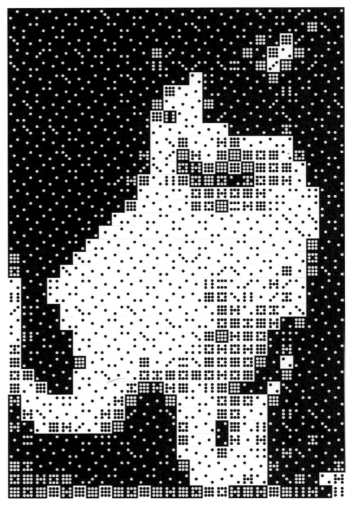

Employing the same technique, it is possible to apply different shapes to the tiling of your target image. For instance, to tile the photograph of the boxer Muhammad Ali on the next page, I created thirteen distinct square tiles depicting the modulation of a square (square rotation + reducing; see fig. below).

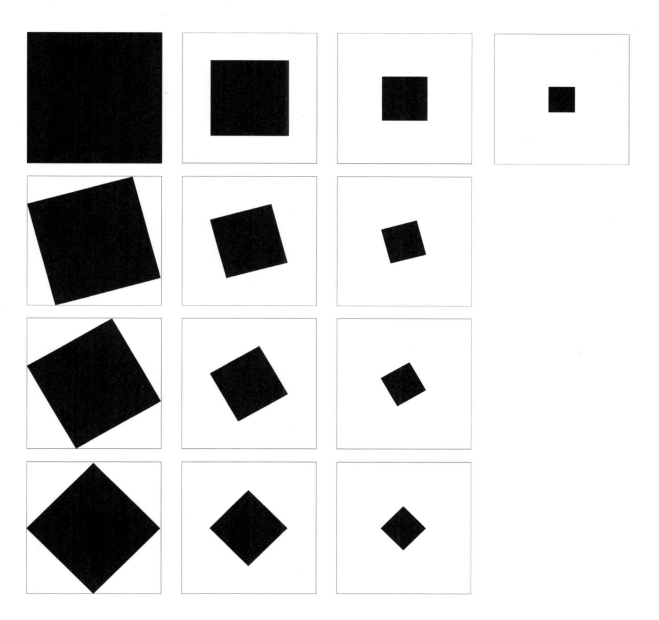

In this eye-catching example the target image is an old photograph showing the boxer Muhammad Ali in action.

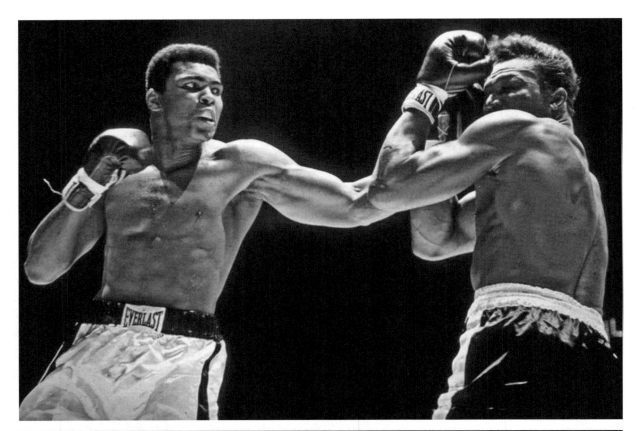

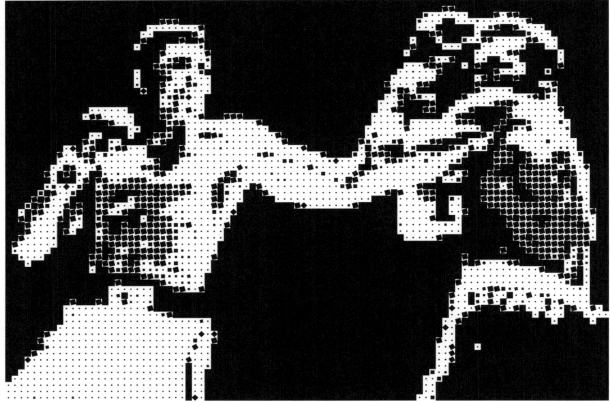

With this technique you can also create a composite image from any self-portrait. In the example below, I used a picture of my stepfather, Marcel. With MacOsaiX or Ezmosaic you can import images from the web that will compose the target image. I selected Google in the "new source" field and entered the terms "train" and "locomotive," because I know that Marcel is passionate about trains. Then I clicked "Save" and the software generated a composite image entirely made out of locomotives and trains. If you view the image from a distance it will be remarkably well defined.

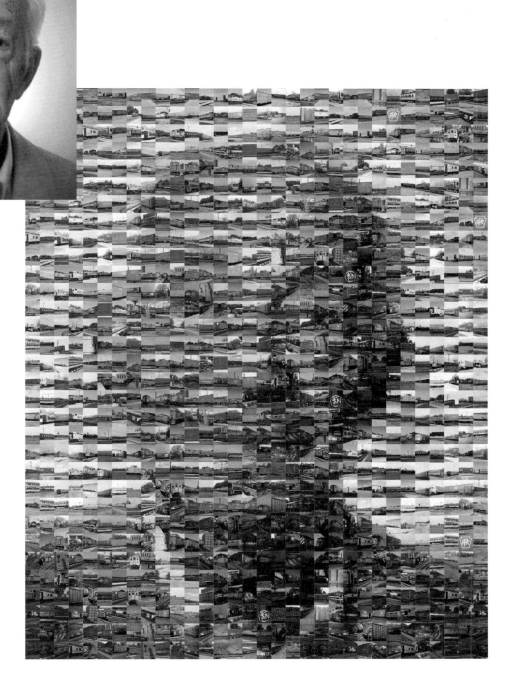

A child, many children . . .

Using the same application, I created this variant representing a small child. If you look closely, you may see that the face is tiled in with exactly 143 pictures of children, representing various countries.

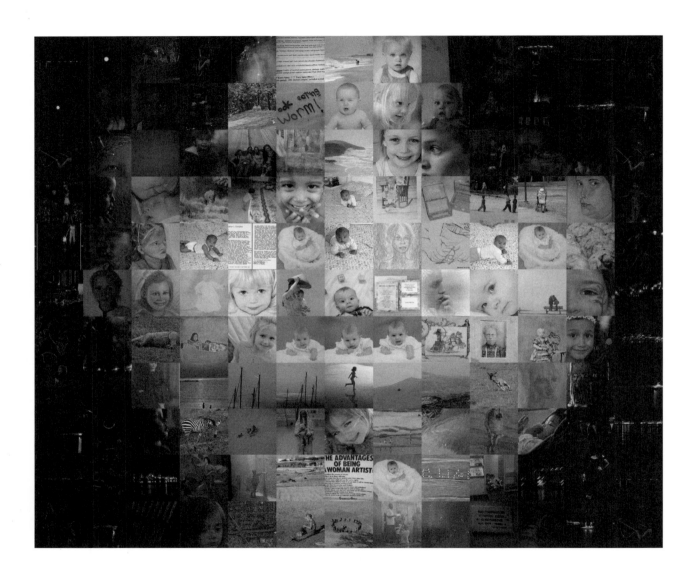

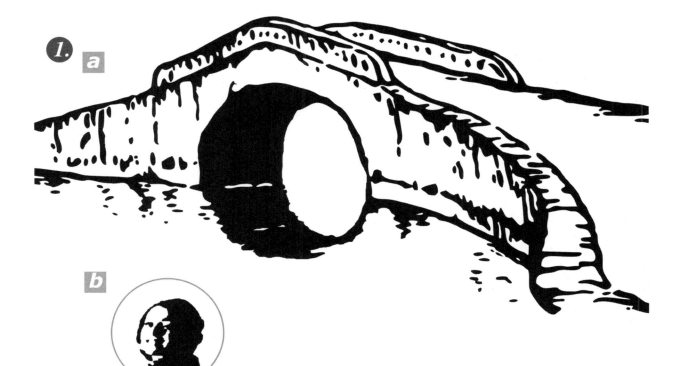

1. **a**

b

Our brain is great at recognizing or perceiving faces even in random objects such as clouds. "Face illusions" are ambiguous images that exploit similarities between two or more distinct images. They are also known as reversal images, puzzle images or perceptual rivalry.

It is relatively easy to embed faces within arches, arcades or any arc-like structure. I will show you how to transform a simple clip-art picture representing a bridge into a puzzling one.

Above is a drawing of a stone arc bridge (Fig. 1a). This time, to create the visual ambiguity, we will take advantage of the high black-and-white contrasts. I found in an old journal an ad featuring a highly contrasted picture of a woman (Fig. 1b). I made a mirror copy of her head, enlarging it so that it fits perfectly into the arc beneath the bridge (see Fig. 2a).

2. **a**

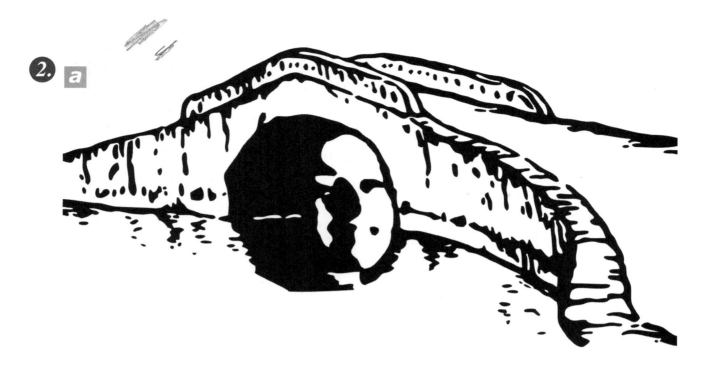

To finalize the picture, I added color and some extra visual details, along with the figure of a rowing man (Fig. 2b).

b

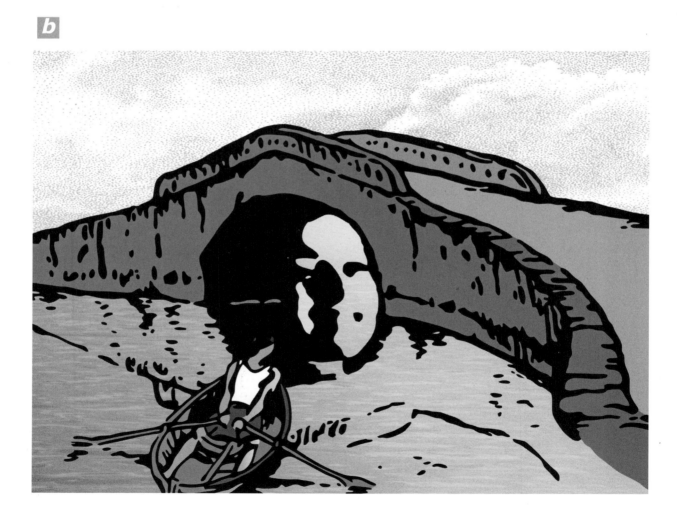

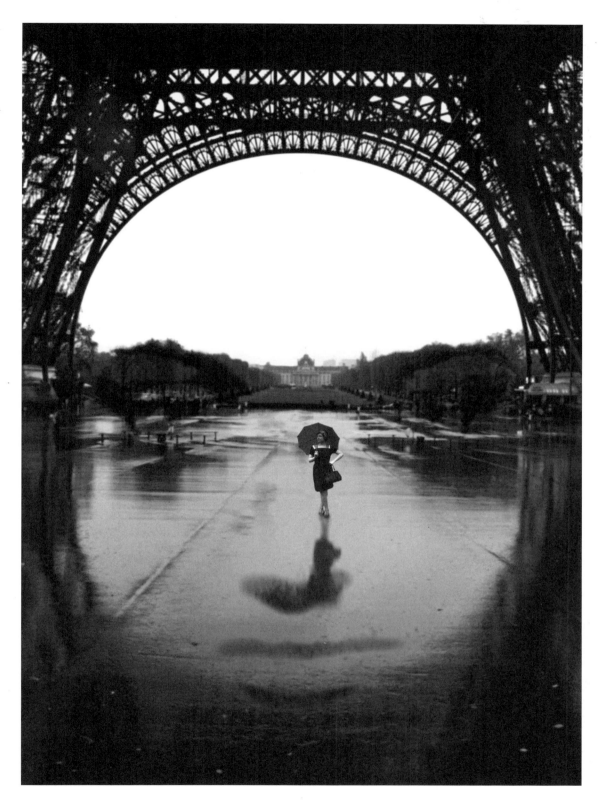

This is almost the same technique I used to create this face illusion picture called "The Other Face of Paris." Can you find a mysterious person in this vintage photograph of the Eiffel Tower? If you look at the center of this photograph for a while, a face will suddenly emerge.

With repeating oblique stripes we can make very interesting cryptic illusions. We will actually create a labyrinth that hides a puzzle caption indicating that in the set of oblique lines is hidden a "girl face." Yes, I purposely use ambiguous language in order to misdirect the reader; yet finally a GIRL FACE is really present in the picture in the form of capital letters.

We will first need a pattern to use as a background. Draw evenly spaced oblique lines or photocopy a pattern of oblique lines from a graphic design notebook.

1.

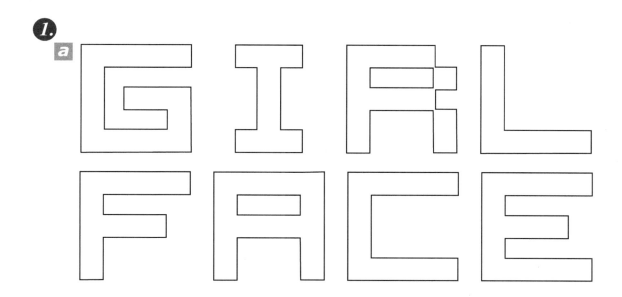

In large block capitals write "GIRL FACE" (Fig. 1a), and reproduce within the body of the fonts the same oblique lines of the background but mirror-imaged (Fig. 1b)—that is, reversed in their orientation from the oblique lines of the background.

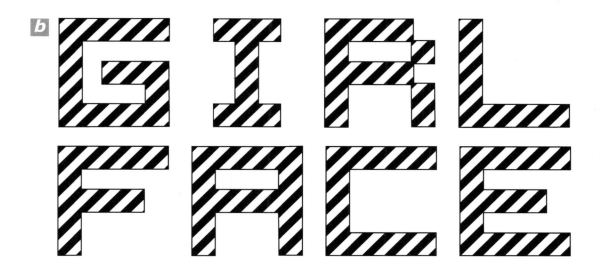

Then, cut out the capital letters and arrange them on the striped background, as shown in the example below. Once you are satisfied with the graphic disposition of the letters, stick them onto the background and reproduce the final composition with tracing paper, making sure to trace only the diagonals and ignoring the contours of the letters.

If you did it correctly, the drawing should appear like a labyrinth (see the example in Fig. 2a). Use your drawing as a pattern and play with it by exploring various graphical ways of presenting it. In Fig. 2b I just made a negative of the drawing.

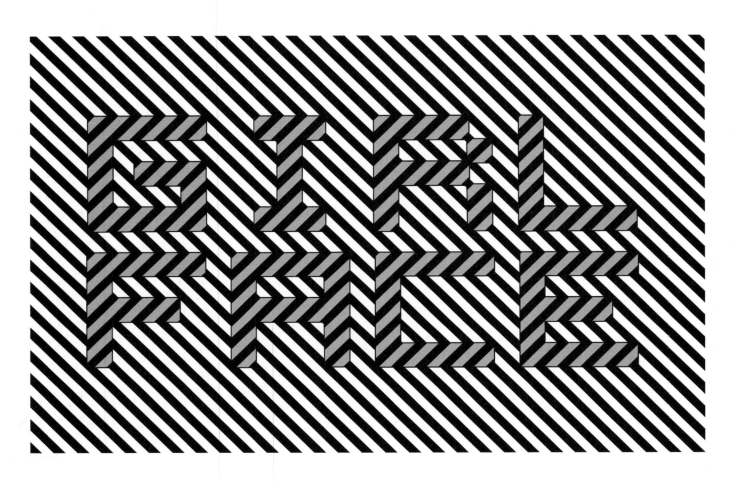

a

b

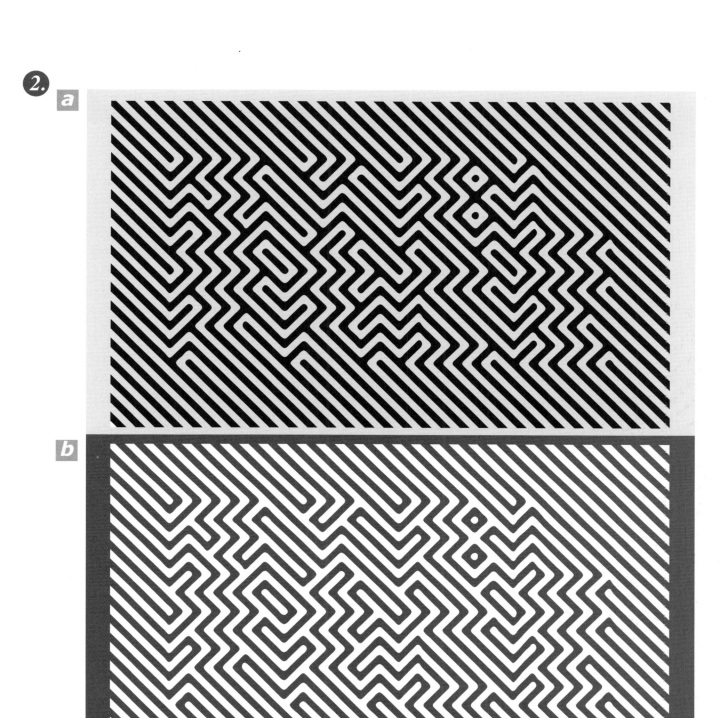

Impossible Figures

We may have come a long way in drawing, understanding and sharing images, but there are some types of images that still have the ability to perplex and bemuse us. In fact, small and apparently insignificant errors in a drawing can produce objects that seem normal on paper but cannot exist in our real world.

When the outlines, lines and vertices of a shape are incorrectly joined together, the result is called an impossible figure—that is, a figure that at first looks normal and consistent but cannot actually exist. The more normal an impossible figure looks, the more fascinating it becomes! Impossible figures reveal important insights into how the mind constructs a three-dimensional object from a two-dimensional image.

A sort of miracle occurs when we trace lines to depict an object. Thanks to a drawing technique called "linear perspective," the flat picture is transformed in the mind into a three-dimensional scene, without any conscious effort on our part. However this insistence on seeing the three-dimensional can also lead to some interesting perceptual problems.

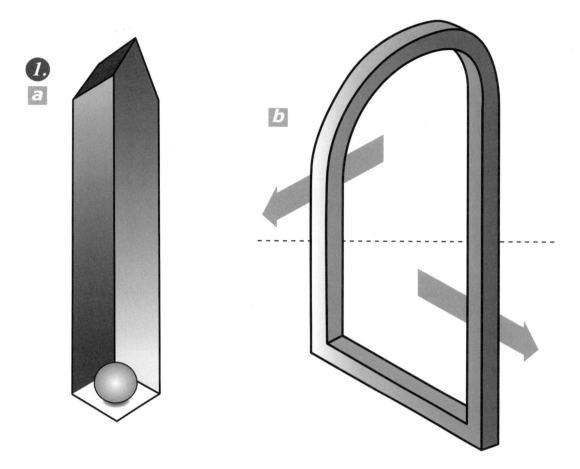

What exactly are "impossible figures" or "impossible objects"? How can line drawings of solid or tridimensional structures seem plausible and real when they are in fact illusions? When part of a depicted object has conflicting depth or position cues (such as ahead/behind, front/back, inward/ outward, above/below, top/bottom, or vertical/horizontal), chances are that you are in the presence of an impossible figure. For instance, take a look at the picture in Fig. 1a, representing a kind of bell tower. The architecture of the tower does not convince: the central vertical edge that joins together the two isometric faces of the tower combines contradictory depth perspectives; its lower part seems to recede, leaving an empty square space, while the upper part seems to advance to create a volume (a prism). In the example in Fig. 1b, we encounter a similar paradox: the left upper part of the gate framework seems closer to the viewer, but so does the right lower part, and that is simply impossible in our real world!

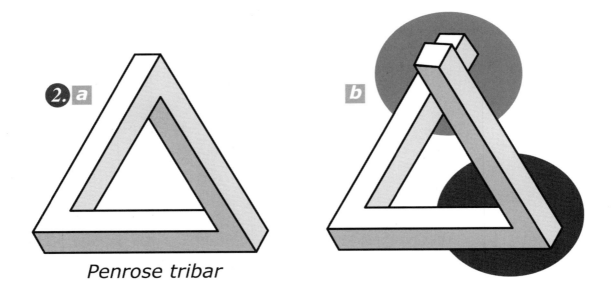

Penrose tribar

Other examples include the well-known impossible figures called the *Penrose tribar* (Fig. 2a) and the *Penrose staircase* (Fig. 3a), which contain ahead/behind and top/bottom depth-contradictions respectively. When you look at the Penrose tribar as a whole, it appears to be made up of three straight beams of square cross-section joined at right angles to form a triangular frame. But curiously enough, the beams appear to simultaneously recede and come toward you! However, if you cover up the top corner of the tribar, the three beams appear to meet together properly, at right angles to each other, in the bottom two corners. If you were to remove your hand again, a normal figure would look like Fig. 2b. As you can see, the two top bars not only wouldn't meet, they would not even be near each other if they were joined properly in the bottom two corners.

We find a similar paradoxical situation with the Penrose staircase (Fig. 3a). This is a two-dimensional depiction of a staircase in which the stairs make four ninety-degree turns as they ascend or descend, yet form a continuous loop, so that a person could climb them forever and never get any higher. Have a look at Fig. 3b. Can you say which ball is placed on the lower step—the light-gray or the dark-gray one? No doubt you will find it difficult to answer . . .

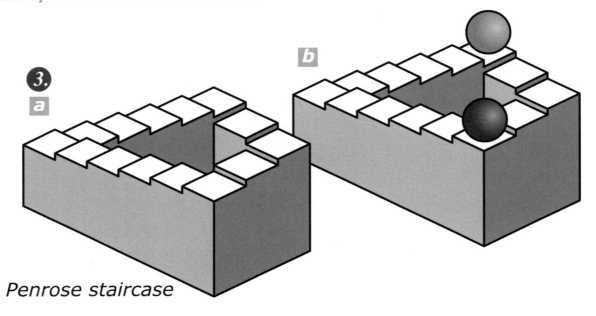

Penrose staircase

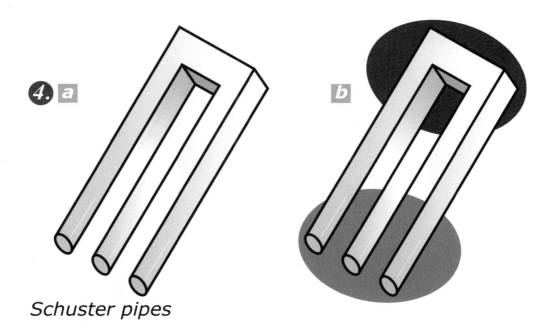

4. **a**

Schuster pipes

b

Other impossible figures play with figure/ground reversal: some of their contour lines can be perceived either as solid or as blank space (background). Take for example Fig. 4a, another notable impossible figure called a *Schuster pipe* (but best known as the *devil's fork*). If you cover the bottom part of the image, it appears as an object with two rectangular prongs. But if you cover the top part, it appears to have three cylindrical prongs (see Fig. 4b). When the entire object is viewed at once, it seems to switch between having two and three prongs. Though the printed object seems visually consistent on paper, this paradox confuses the mind! The space between the prongs becomes either solid or void at the opposite ends of the object.

In this respect, other drawings including slats or stairs can also be confusing. For example, does the notable impossible figure called *Ernst stairs*, shown in Fig. 5a (on the next page) have two or three steps? What is wrong with this model? If you try to color the risers and the treads in different shades (or colors), you will notice that the intermediate tread cannot be filled with just one shade or color (see Fig. 5b). This is because the riser (vertical plane) and the flat (horizontal plane) seem to be paradoxically blended together! We encounter the same perspectival problem with the stair-like structure shown in Figs. 6a and 6b: here too treads and risers are confusing, as the steps appear protruding or caved-in, depending where you look.

5. **a**

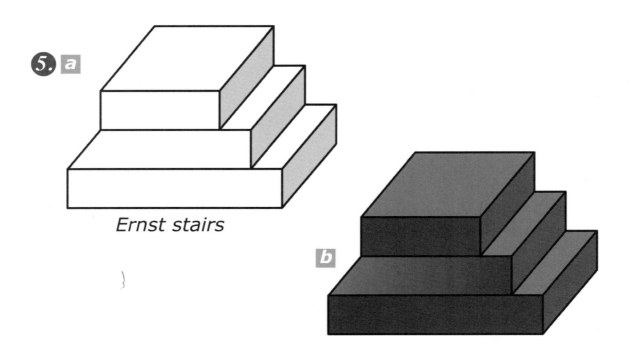

Ernst stairs

b

6. **a**

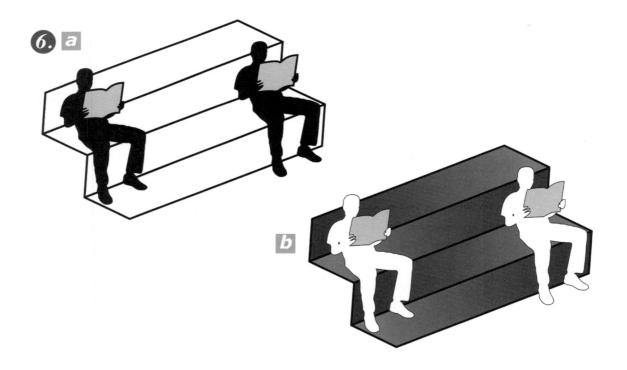

b

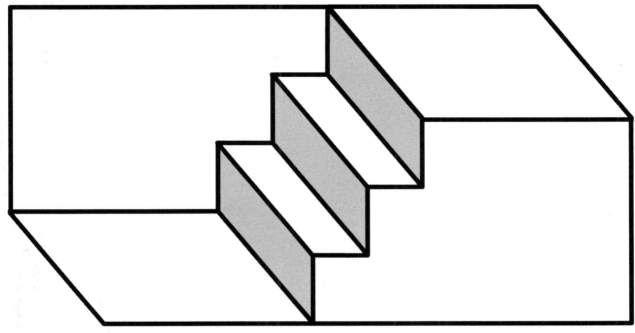

Schröder staircase

We conclude the presentation of the most important types of impossible figures with the notable ambiguous figure called the *Schröder* or *Schouten staircase* (see figure above). Most likely you perceive the staircase as placed on the ground with the stairs climbing to the right. Now, try looking at the upper left-hand part of the drawing and imagine that it is the closest thing to you in this picture. Suddenly, the staircase flips, and it is as though you are seeing the stairs from below! This is not strictly speaking an impossible figure but an ambiguous figure, because it gives rise to two contrasting perceptions.

PENROSE TRIBAR

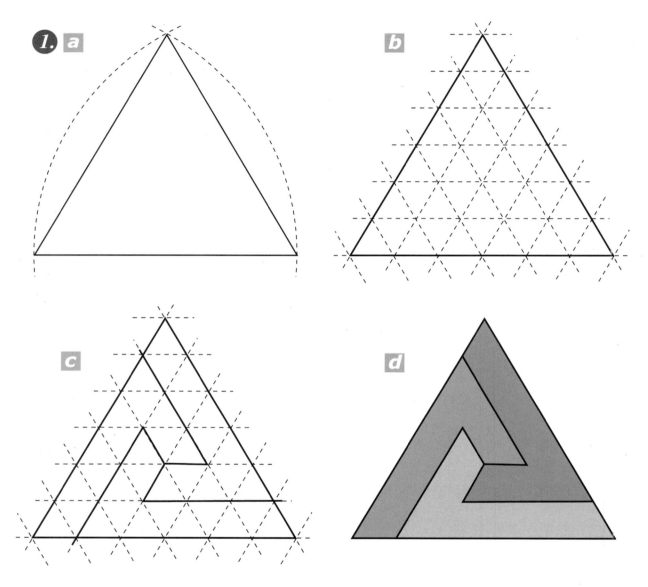

The tribar or Penrose triangle was actually not "invented" or "discovered" by British mathematician Roger Penrose, because the preconditions of its existence were already present in Greek and Arabic ornaments (tiling, friezes). The examples in Fig. 1 show how to design the basic Arabic frieze, which can be easily transformed into a tribar (see the steps in Fig. 2 on the following page).

So, first draw an equilateral triangle as shown in Fig. 1a. Then divide each side of the triangle into six equal parts and trace lines to form a triangular grid (Fig. 1b). Next, from the center draw three broken lines following the lines of the grid, as depicted in Fig. 1c. Eventually, color the three "arms" of the decorative model with different colors.

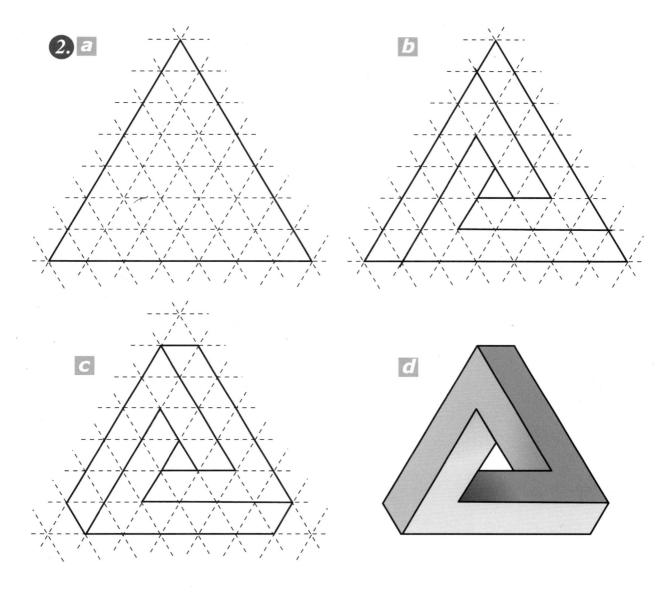

Using the same technique, you can now create a tribar. The only difference is the number of parts into which you must divide the initial triangle: seven instead of six equal parts. Following these four simple visual steps you will obtain the impossible triangle found in Fig. 2d.

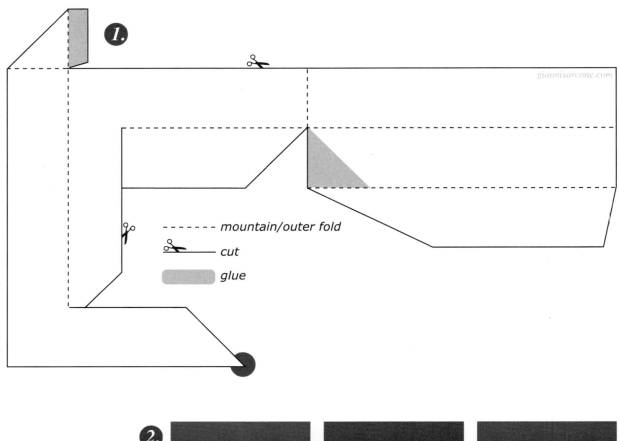

1.

- - - - - mountain/outer fold
⊱— cut
▬ glue

giannisarcone.com

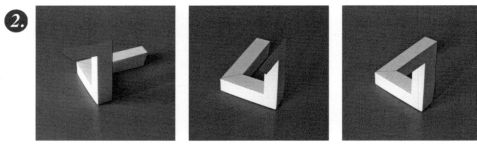

2.

Reproduce, cut and assemble the pattern above—following the simple instructions in Fig. 1—to make your own 3D tribar model.

As you will see, this physical tribar model only works visually from one particular angle that you will have to find with the help of your camera (Fig. 2). Depending on the distance between your camera and the physical model of the tribar-to-be, you may adjust the model and try different lengths for the edge marked with the dark-gray spot. You may also want to snip its corner angle to get the lines to fit the background of the model exactly.

SARCONE STAIRS

1. **a**

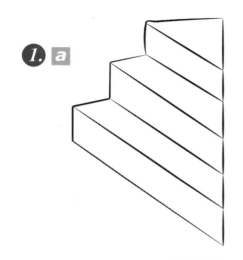

Here is a neat impossible figure of my invention you can draw in very few steps. Draw a staircase with three steps as shown in Fig. 1a. Extend then the treads and the risers in a kind of virtual growing spiral (Fig. 1b). The result will be a spiral stair combined with normal stairs (Fig. 1c).

Erase completely the lines that divide the two kinds of stairs (Fig. 2a). Now, two treads of the stairs on the left are blended with two risers of the spiral stair. You can color the treads of the spiral stair with solid color, but you will obtain the best visual effect if you apply to the blended treads and risers color shading. To finalize your project, you can enhance the feeling of volume by adding atmosphere, objects, people or animals to the drawing, as depicted in Fig. 2b.

b

c

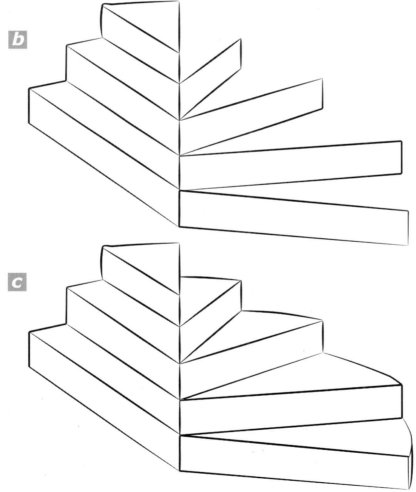

2. **a**

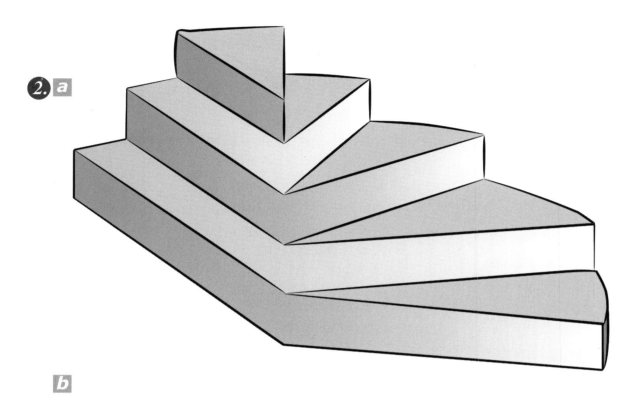

b

1. **a**

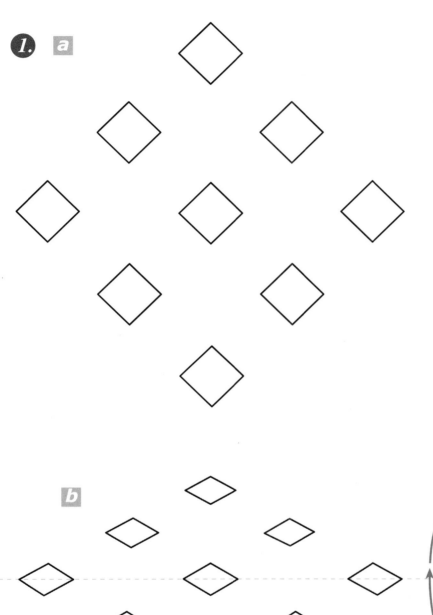

b

In this section, we will draw a set of impossible pillars using some angular perspective. I suggest you employ for the purpose of this exercise a vector graphics editor such as Illustrator or Freehand.

First draw a square arrangement of nine squares/diamonds as shown in Fig. 1a; then 3D-rotate it (Fig. 1b).

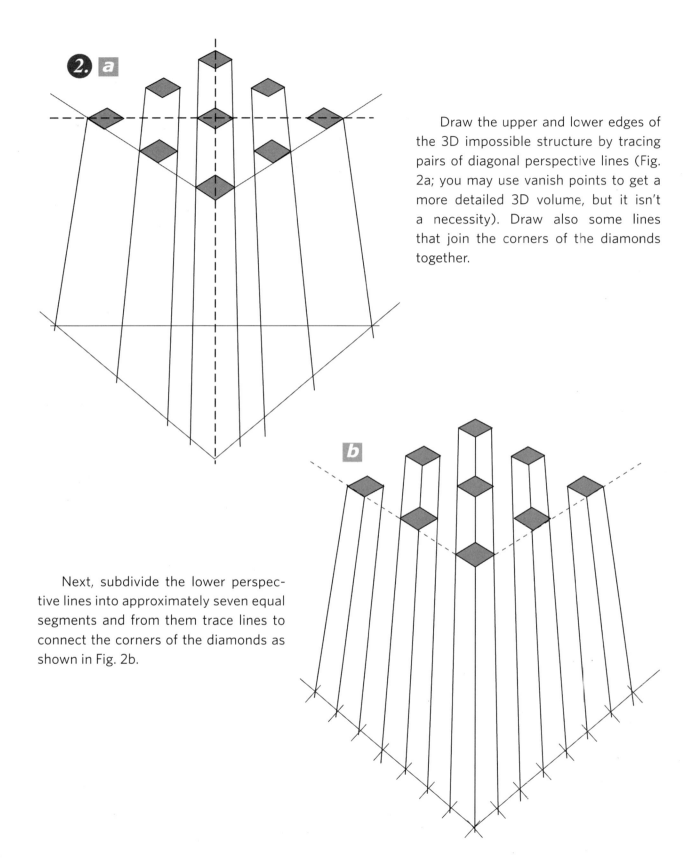

Draw the upper and lower edges of the 3D impossible structure by tracing pairs of diagonal perspective lines (Fig. 2a; you may use vanish points to get a more detailed 3D volume, but it isn't a necessity). Draw also some lines that join the corners of the diamonds together.

Next, subdivide the lower perspective lines into approximately seven equal segments and from them trace lines to connect the corners of the diamonds as shown in Fig. 2b.

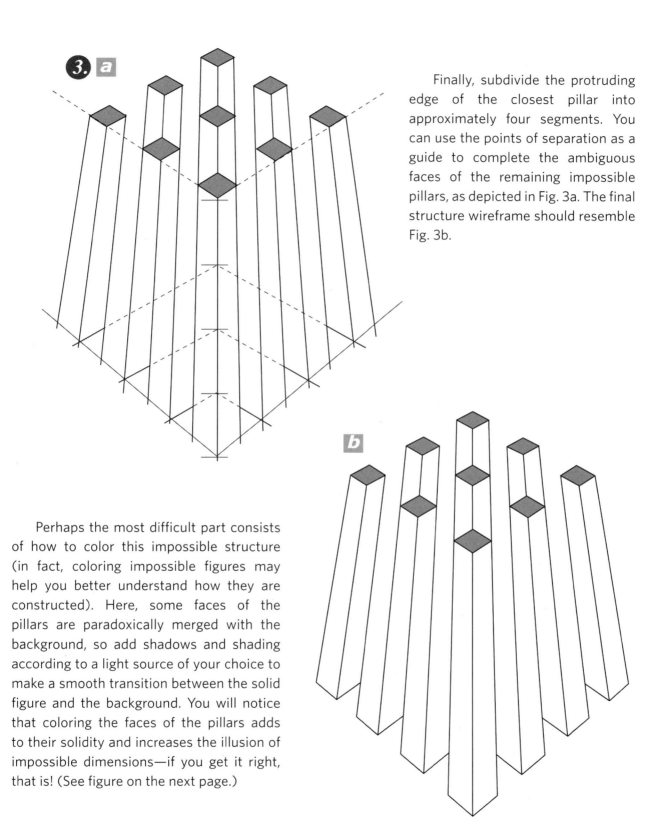

3. a

Finally, subdivide the protruding edge of the closest pillar into approximately four segments. You can use the points of separation as a guide to complete the ambiguous faces of the remaining impossible pillars, as depicted in Fig. 3a. The final structure wireframe should resemble Fig. 3b.

b

Perhaps the most difficult part consists of how to color this impossible structure (in fact, coloring impossible figures may help you better understand how they are constructed). Here, some faces of the pillars are paradoxically merged with the background, so add shadows and shading according to a light source of your choice to make a smooth transition between the solid figure and the background. You will notice that coloring the faces of the pillars adds to their solidity and increases the illusion of impossible dimensions—if you get it right, that is! (See figure on the next page.)

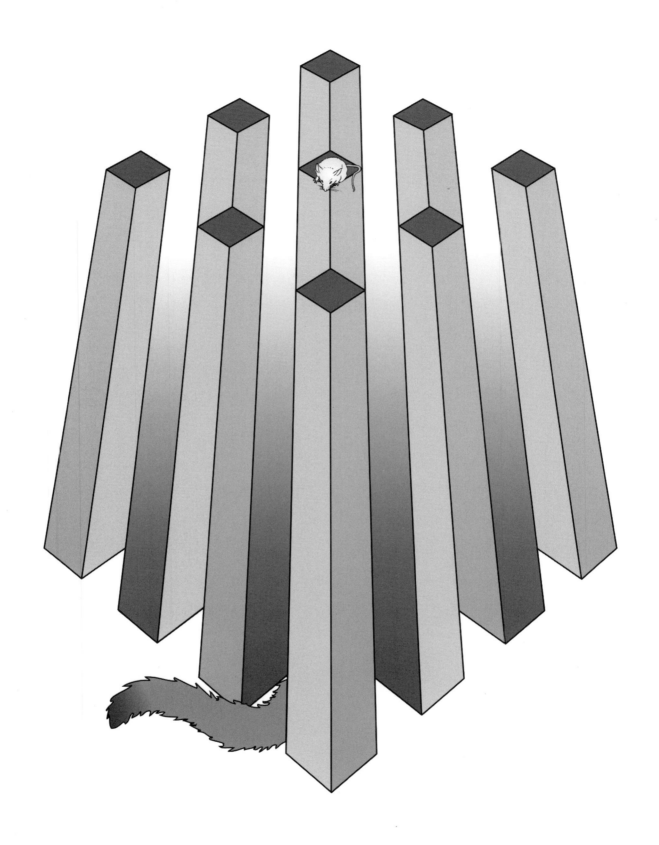

1.

2.

To create this illusionistic tiling you just need a simple basic chevron element that can be generated from a perfect square.

Draw a square and, using a pair of compasses, trace a circle centered on a corner of this square, so that the perimeter touches two of its other corners. Now, with the help of a protractor, draw within the circle a rhombus with opposite sides angled at 120 degrees (Fig. 1). Crop out a portion from the rhombus, as shown in Fig. 2. Finally, by a rotation of 120 degrees and reflection, you will obtain the cell shown in Fig. 3a.

In the final picture, you can see that by repeating the basic cell as shown in Fig. 3b, you will obtain an intriguing impossible net of parallel bars in oblique projection (see figure on next page).

3. The cell (a) and the spatial distribution of the cells (b).

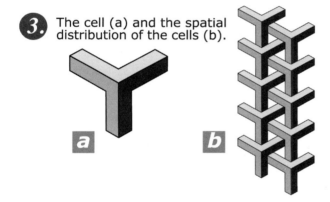

a

b

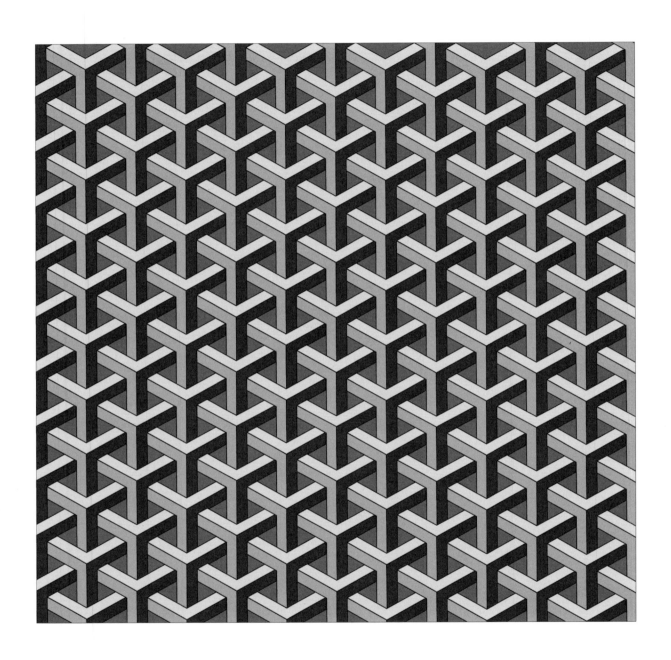

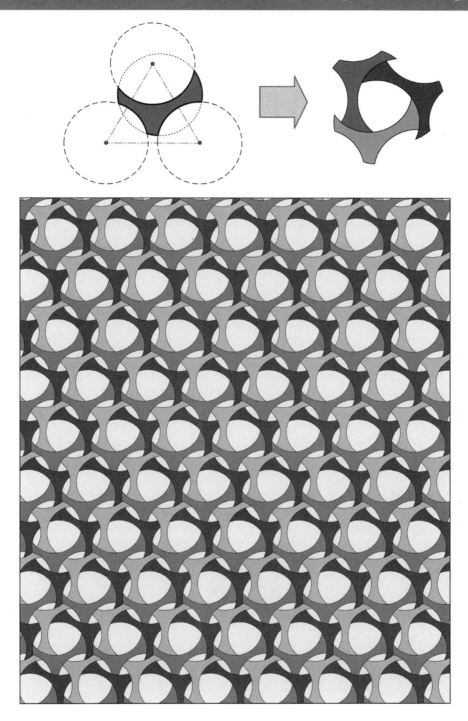

I will conclude our journey into the world of impossible figures with some easy-to-make yet amazing impossible patterns involving holes that create intriguing optical effects. These patterns are great for designing wrapping paper or any other decorative item. I think the visual tutorials are clear enough.

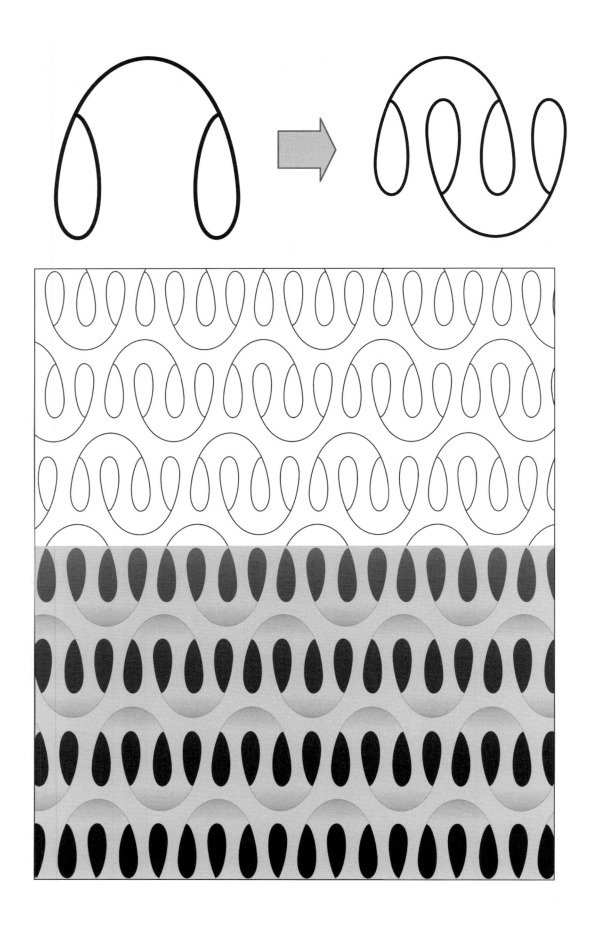

It Moves

Motion is ingrained in life, though some objects move very quickly (such as electrons) and others so slowly (a growing tree, for example) that they seem static.

Seeing a stable world while we are moving (which we do all the time without being aware of it) requires such elaborate visual compensations that sometimes something in the process goes wrong. For instance, when a stationary small and dim light such as a lit cigarette is observed for several minutes in a very dark room, it seems to move and swing around, usually in a fairly random path. This is due to small movements of the eyes called "saccades" that are not monitored by the brain. Everyone experiences some eye drifting, or saccades, because it is very demanding for the eyes to maintain a steady and accurate gaze when you look at an object.

In the world of optical illusions, the terms "autokinetic illusion" or "apparent motion" are used to describe the convincing appearance of movement in a picture that the viewer knows to be static. This particular form of visual trickery has a long history. Ancient Romans were aware of how to create the illusion of movement, applying their knowledge of optics and perspective to create amazing illusive mosaic floors that fool the eye into thinking they are rotating slightly. During the 1960s, the Op Art movement—the leaders of which were Victor Vasarely, Richard Anuszkiewicz and Bridget Riley—began experimenting with new visual concepts designed to trick the eye and stimulate the brain. Op Art paintings and exhibits play with interferences and moiré effects to create illusory colors and to simulate motion.

There is an ongoing debate about what generates the illusion of movement in our visual system, and a number of conflicting theories. What we know for sure is that repetitive patterns, shades and high contrasts induce strong illusory movement effects.

The use of a vector graphics editor and Photoshop is not always required, but it is the quickest way to create amazing autokinetic illusions.

ROTATING SPIRAL

We will here design a pattern that looks like a spiral (but it isn't!) and seems to rotate. Draw a set of eight or nine diagonal paired lines as shown in Fig. 1a. Then draw a set of fifteen or sixteen paired lines in perspective crossing the diagonal lines (Fig. 1b).

2.

a

Now you can use this grid as a guide for tracing a stair-shaped strip (Fig. 2a). You'll notice that to get the best final rendering you have to progressively decrease the height of the risers.

b

Reproduce the strip in different colors (black, dark gray, white, light gray) and combine them together to obtain a unique, larger stair-shaped ribbon (Fig. 2b).

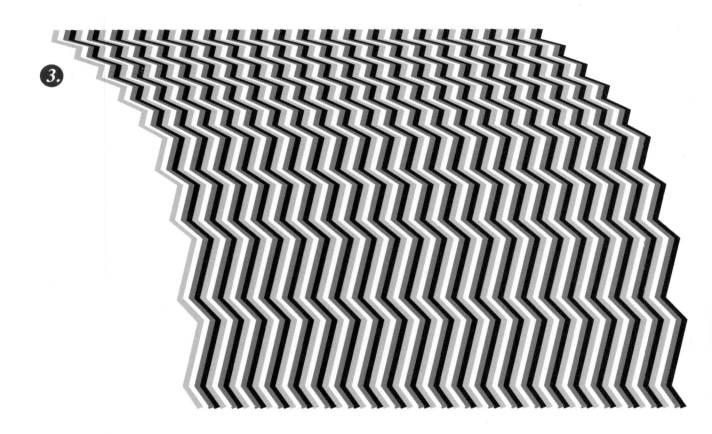

Reproduce then the shaded ribbon as many times as necessary to obtain a pattern that could cover a large square (Fig. 3).

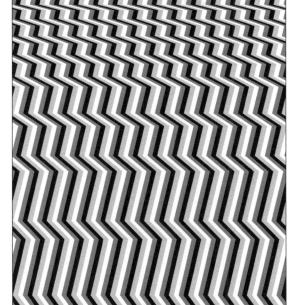

Next, copy the pattern and paste it into a rectangle (Fig. 4a). You must select and adjust the borders of the rectangle so that the left edge of the pattern matches with the right (see Fig. 4b).

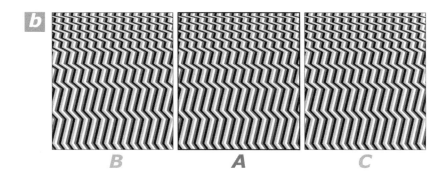

B A C

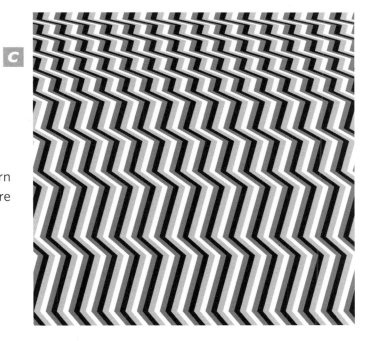

To conclude, import the rectangular pattern into Photoshop and resize it in a perfect square (Fig. 4c).

Once you have the image imported and resized, go to the menu and choose "Filter," then "Distort," and then "Polar Coordinates." Then click on the "Rectangle to Polar" option. You can see a small preview of your final image, and, depending on the size of the image and speed of your computer, you will get your amazing rotating spiral in a few seconds! Magic, isn't it?

How many spirals can you see? You may see one large illusive spiral, whereas there is really a series of concentric circles. Moreover, the spiral-like pattern seems to rotate slightly. And as you know, the image is perfectly static.

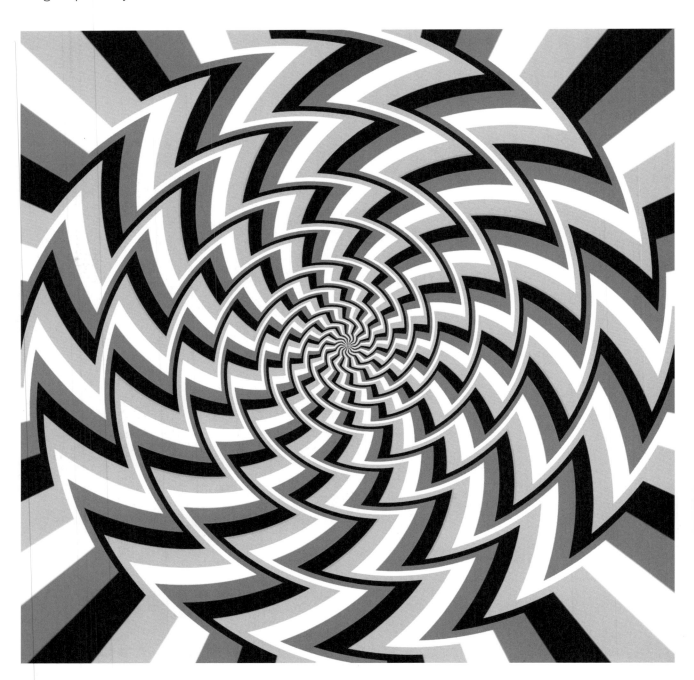

EXPANDING HEART

In the following pages, you will discover a new kind of optical illusion of my invention, involving expansive motion created by/with parallel arrangements of cuspidate (needle-shaped) lines.

First create a parallel arrangement of needle-shaped items as shown in Fig. 1.

 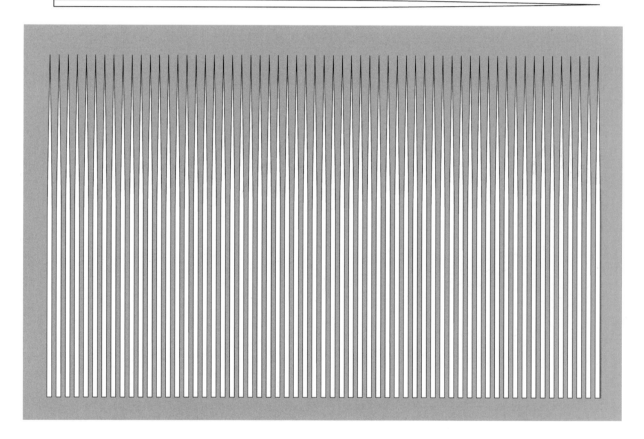

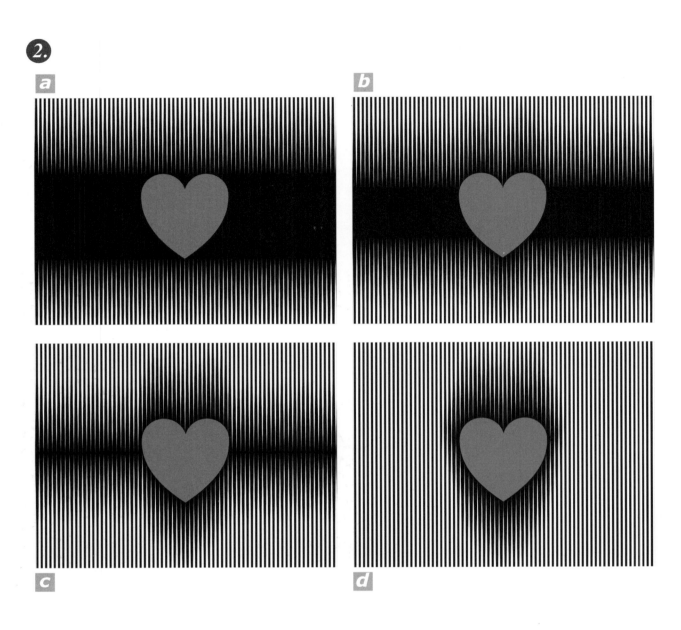

Next, make two sets of this arrangement and place them on a black background (Fig. 2a). Let these two opposite sets interpenetrate, leaving a blank space delimited by the outline of an arbitrary shape of your choice, for instance a heart (here, in gray, see Figs. 2b through 2d).

In the final rendering of the illusion, when the gray shape is removed, the dark heart magically starts to pulsate and/or expand (moreover, if you stare for a while at it and close your eyes, you will see a white heart appearing in your head!). As an aside, this optical illusion design was named in the top-ten best optical illusions in the "2014 Best Illusion of the Year Contest" held in St. Petersburg, Florida.

How does this illusion work? This optic effect by its nature is quite opposite from another illusion called "Troxler's fading" or vanishing effect, but it works in the same way. The solid central "black heart" is not expanding at all; rather, its outer surrounding, which looks like a blurred halo, is slowly shrinking (in fact, dissolving) due to lower visual stimulus in comparison with the striped background and the plain black zone, thus giving the impression the solid black heart expands and pulsates.

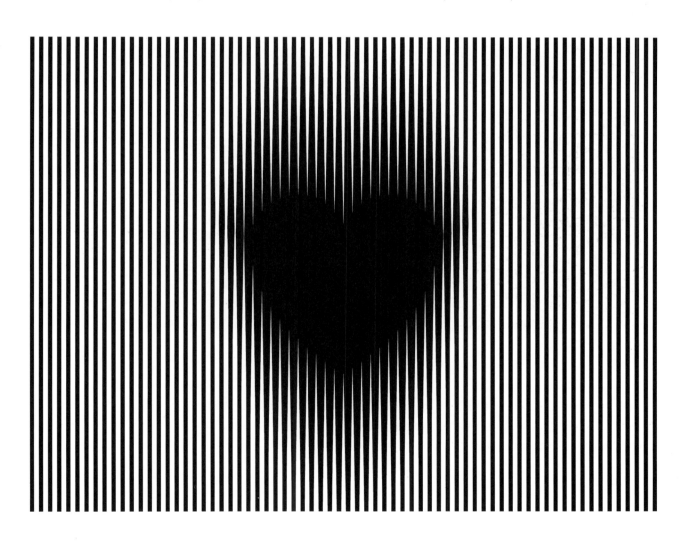

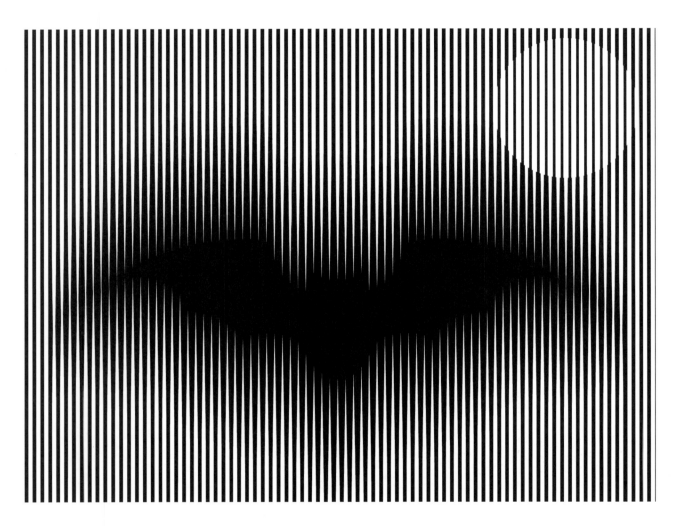

With the same principle you can create more complex figures. In fact, the illusion works even with complex contours. Look at the picture: the black bat seems to flutter, pulsate and/or expand!

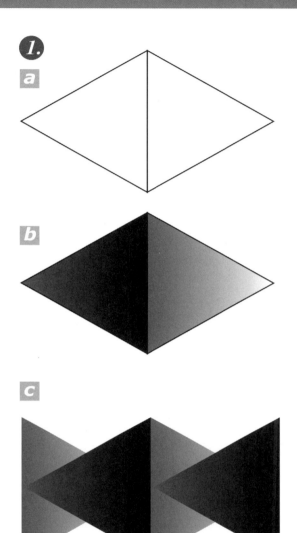

1.

a

b

c

After rotating, expanding illusory movements, let's try something different: a continuous ascending/descending movement of droplets. Here we go.

Draw a triangle and its mirror image as depicted in Fig. 1a. Add graduated shading to both triangles: one with black to dark gray, the other with gray to white gradation (Fig. 1b). Erase the contours of the geometric shapes and form the first cell (Fig. 1c), which will allow you to create this amazing illusory two-way motion.

Starting with the basic cell, prepare now a series of triangle "garlands," each being one diamond-unit larger than the previous one, as shown in Fig. 2a. Then resize and arrange each of these garlands in an imaginary rectangle (Fig. 2b) and set them in equidistant rows (Fig. 2c).

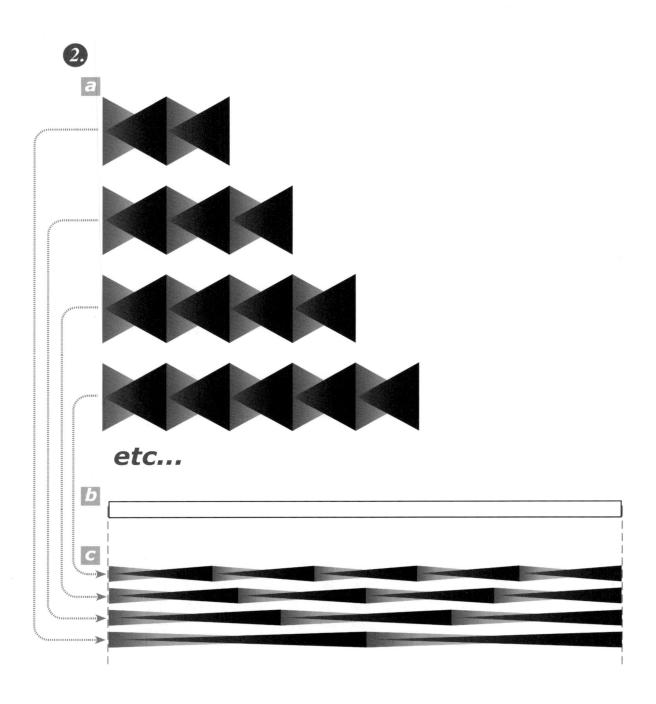

etc...

You can decide how many rows to create with this technique; in the example below, the pattern contains just eleven rows.

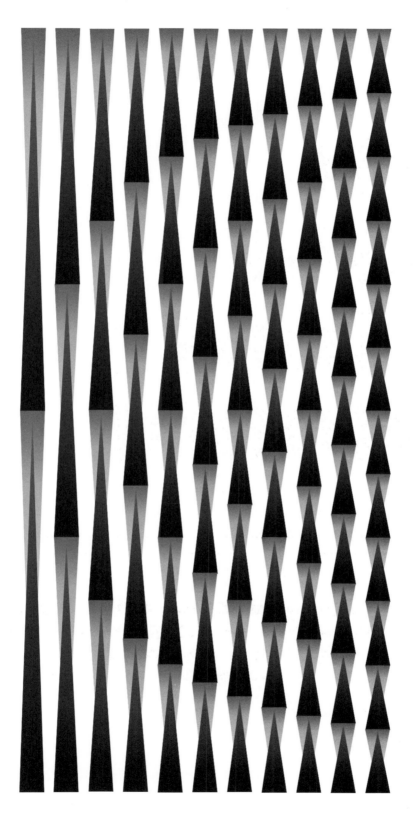

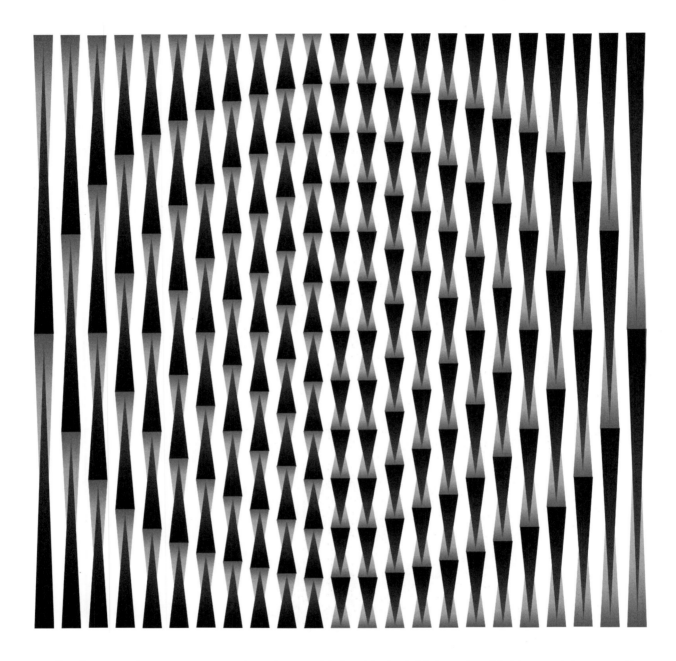

Finally, copy the pattern, rotate it and assemble it with the initial one to obtain a much larger pattern that combines descending and ascending illusory motion, giving an overall impression of droplets whirling.

1.

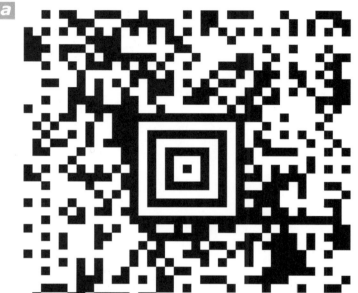

There is an everyday illusion you can experiment with using tickets or receipts. In fact, some QR codes printed on tickets, known as Aztec codes, feature central concentric squares (Fig. 1a) that seem to rise and hover if you stare at them for a while or move them slowly in a circular fashion (Fig. 1b).

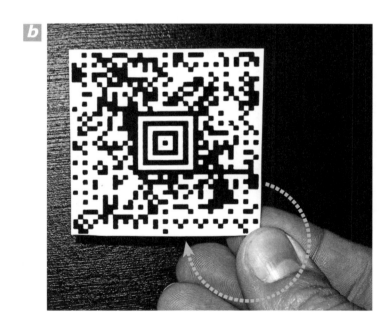

2.

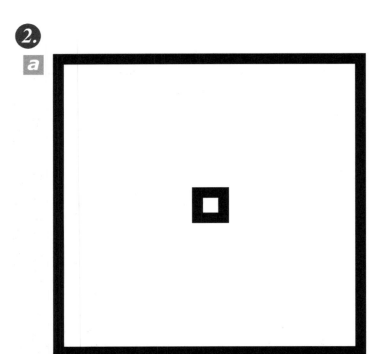

We can create a similar illusory hovering/floating effect using just squares. Draw a large and a small square with thick lines and center them (Fig. 2a). Next, blend the inner and outer squares in six steps to get a set of concentric squares as shown in Fig. 2b.

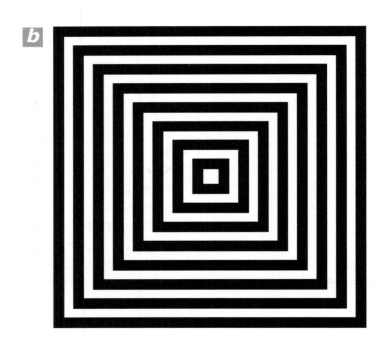

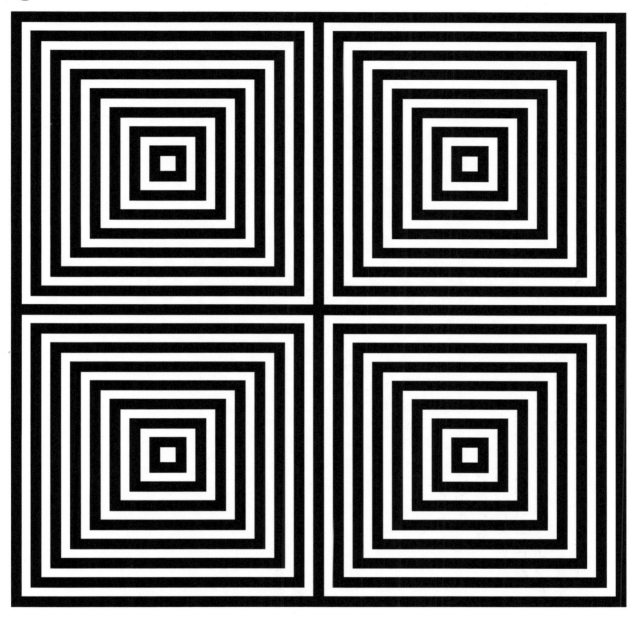

Reproduce the set to form a larger square pattern (see Fig. 3). Eventually, reproduce once again the initial set of concentric squares, turn it forty-five degrees and center it on the larger square pattern (Fig. 4).

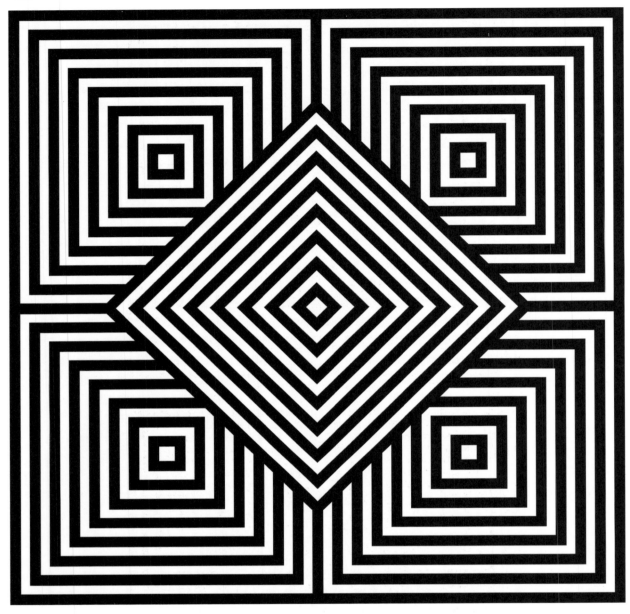

The central diamond seems to slightly float above the contrasted background when you move your eyes around while viewing the figure. Scrolling the image horizontally or vertically gives a much stronger effect. The illusion is caused by the high shape and brightness contrasts and also by random eye movements.

5.

 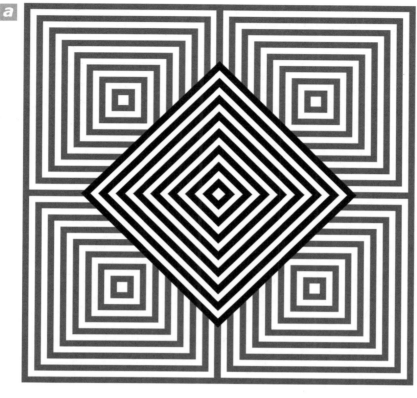

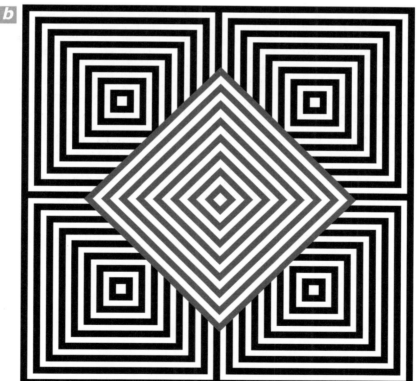

You can enhance the effect by modifying the color of the background (Figs. 5a and 5b) so that the background and central figure have different colors.